Patriotic
MODERN
QUILTS

CAROLE LYLES SHAW

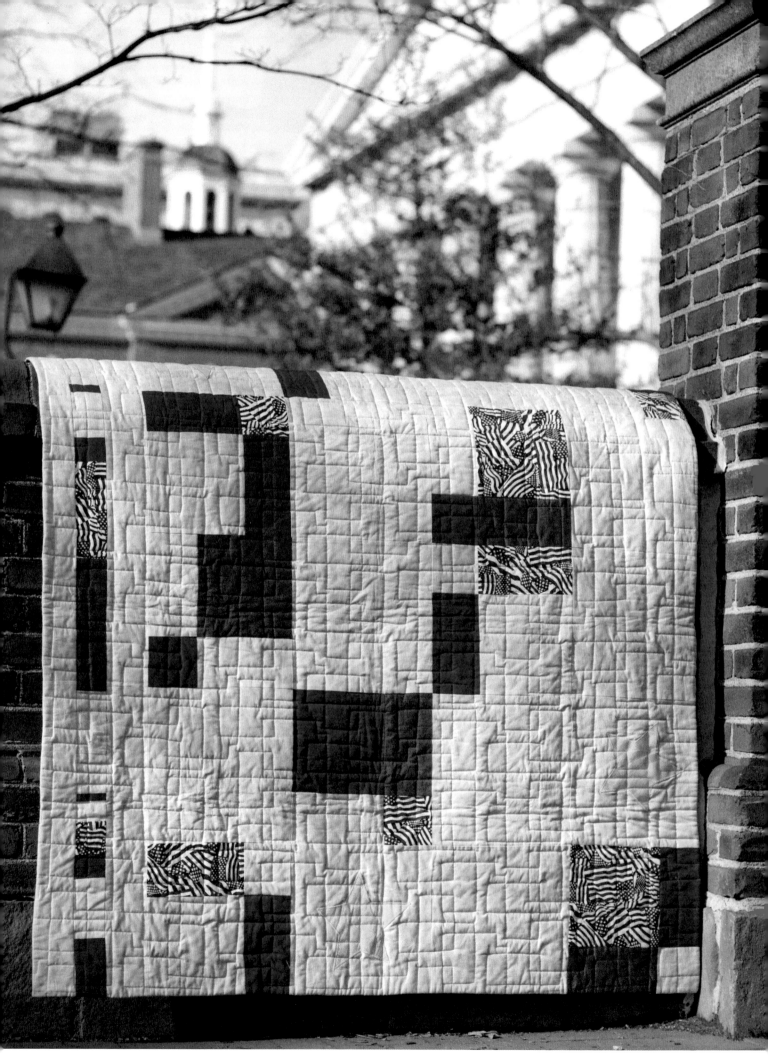

Patriotic MODERN QUILTS

Honoring Tradition in a Contemporary Way

CAROLE LYLES SHAW

PATRIOTIC MODERN QUILTS
Honoring Tradition in a Contemporary Way

NOTE TO WORKSHOP INSTRUCTORS (PAID AND VOLUNTEER):

Workshop instructors are encouraged to use this book
in classes while following the restrictions listed here.
Please contact the author directly for permissions and/or
information on discount bulk purchases so that
you can provide a copy of the book or instructions
to each workshop participant.

Thank you very much for respecting and protecting
the author's intellectual property.

ISBN-10: 0-9907711-2-1
ISBN-13: 978-0-9907711-2-8

Credits
Edited by Lauren Lang and Kathy Cornwell

Graphic Design by Lindsie Bergevin
LindsieBergevin.com

Cover photo and photos shot on location in
Philadelphia, PA, by Kitty Wilkin, www.nightquilter.com.
Quilt photos by Andrea Melendez, Brian James
and James Woo. Used with permission.

Special thanks to my wonderful pattern testers, longarm
quilters and workshop participants for your insight and
support.

Disclaimer
We have made every effort to ensure the accuracy of
the information in this publication. The information in
this publication is provided in good faith, and Modern
Quilter Media LLC assumes no responsibility for losses
or damages incurred in using the materials, techniques,
tools and instructions in this publication. No warranty
is implied or given nor are any results guaranteed.

This book is dedicated to all those who serve at home and abroad to protect our *freedoms* and keep our communities safe.

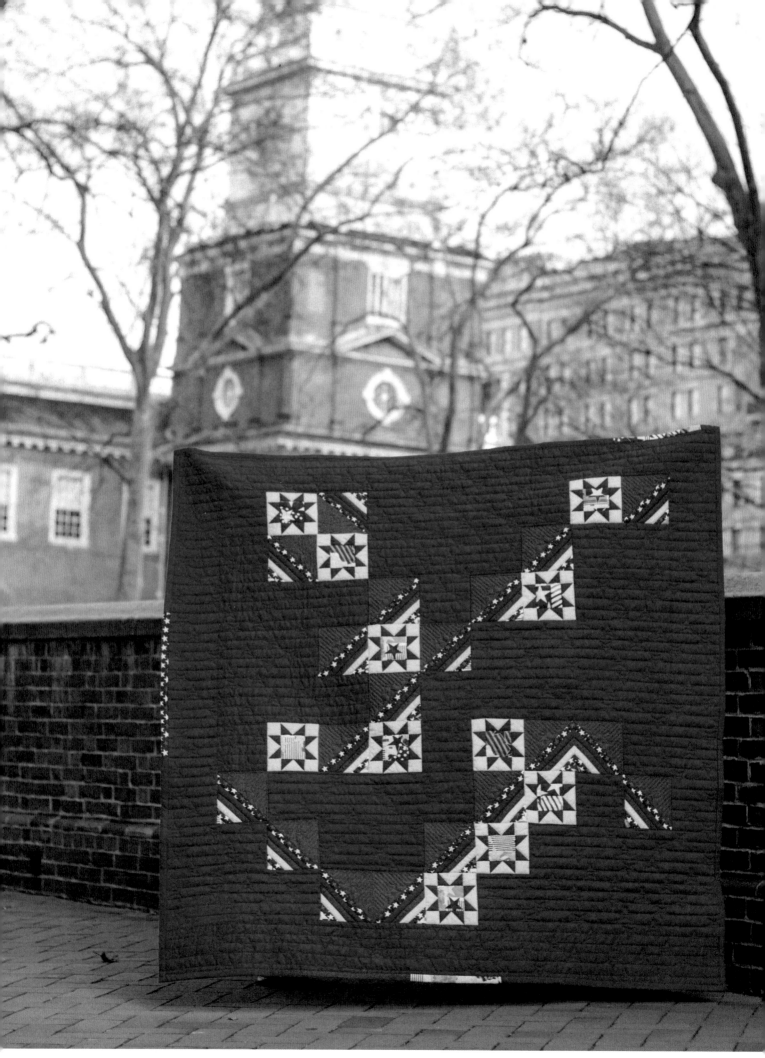

TABLE OF CONTENTS

Projects

Strings & Stars
20

Star with Diamonds
32

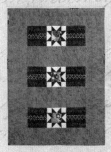

Strips & Stars #1
36

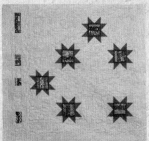

Strips & Stars #2
42

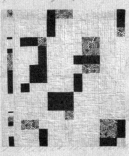

Disappearing Four Patch with Stars 48

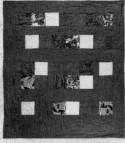

Squares with Improv
54

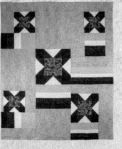

3D Stars & Strips
60

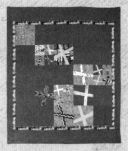

Patriotic X Blocks
66

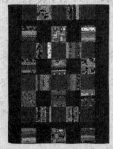

Patriotic Rail Fence
76

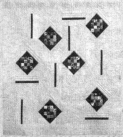

Patriotic Diamonds
80

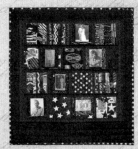

Salute to Heroes
84

My Preamble
INTRODUCTION
TO THIS BOOK

I am very proud to share this book with you. And, you might wonder how a modern quilter like me came to write a quilt pattern book with a patriotic focus. I first became interested in making patriotic quilts a few years ago, but they were not bed quilts—they were art quilts!

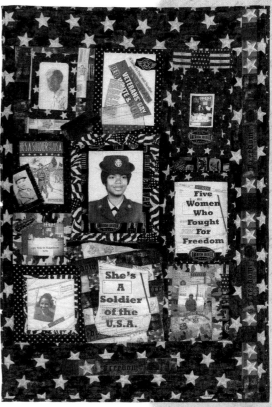

My journey into patriotic quilts began a few years ago when I came across a cache of old family photos and documents from my father, uncles and some of their friends that documented their service in the U.S. military and Merchant Marines. Finding these photos and documents started me on a search for similar materials. I started a small collection by scouring online auction sites. I decided to use this memorabilia in a series of art quilts. My first patriotic quilts were art quilts that honored the service of members of the U.S. Armed Forces. These art quilts had image transfers of materials from my stash of memorabilia about African American men and women who served in the Armed Forces in WWII and Korea.

She's A Soldier of the USA Art quilt. Designed, pieced and quilted by Carole Lyles Shaw.

Then, while I was planning and writing *Madly Modern Quilts,* my first book of modern quilt patterns, I realized that there weren't many modern quilt patterns with a patriotic theme. When I discussed this with my workshop participants, they encouraged me to tackle modern patriotic quilts as my next book project. In addition to designs, my students asked me for advice on fabric choices. Occasionally, a participant would bring patriotic fabrics to my workshops but they had a difficult time choosing patriotic themed prints that would work well as a modern quilt.

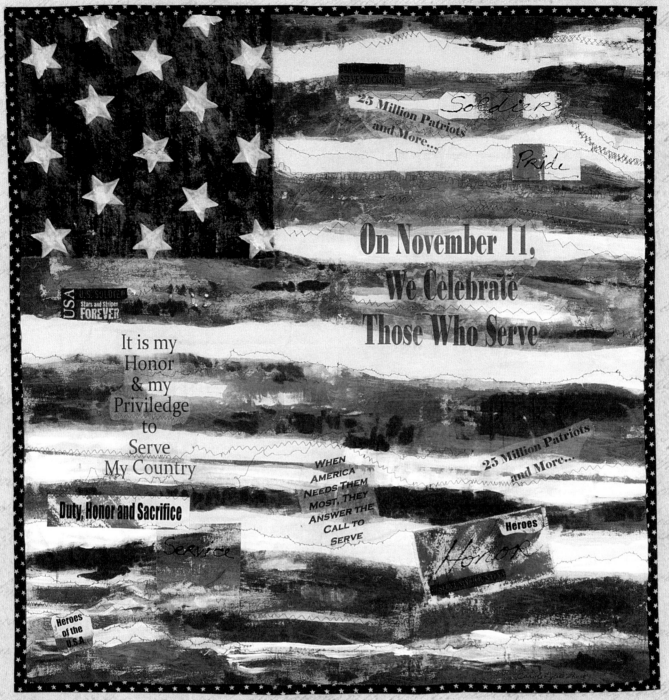

Duty, Honor and Sacrifice Art quilt. Painted and stitched fabric; paper collage.
Designed, pieced and quilted by Carole Lyles Shaw.

In Congress, July 4, 1776

THE UNANIMOUS DECLARATION OF THE THIRTEEN UNITED STATES OF AMERICA

We hold these truths to be self-evident, that all men are created equal,

that they are endowed by their Creator with certain unalienable Rights,

that among these are Life, Liberty and the pursuit of Happiness.

Patriotic Modern Quilts is an opportunity for me to express my fierce and abiding love for my country's founding principles. You'll see quotes from the U.S. Constitution throughout the book. These words call out the best in us, and they are truly what make this country a beacon of freedom for the world.

Finally, I want to give a heartfelt thanks to a special group of friends: the pattern testers and longarm quilters who helped make this project possible. The pattern testers expertly took my draft instructions, pieced the quilts and then offered wonderful suggestions to make the projects even easier for all levels of quilters. My longarm quilters used their talents to bring my designs to life. You'll see their names on the projects as you go through this book.

WHAT IS A MODERN PATRIOTIC QUILT?

For me, patriotic modern quilts are a new twist on a very old tradition. Quilters have been making traditional patriotic quilts for many, many years. Using the patterns in this book will help all quilters to experiment with and explore modern approaches to this tradition.

Don't worry about your quilt being modern enough—these designs will help build your confidence. You may consider yourself a *contemporary traditionalist*—one who's willing to take the best of the quilting tradition and combine it with elements of modern quilting such as improvisational piecing and alternative grid layouts. You may think of yourself as a *modern quilter*—firmly in the swing of this approach to quilt design. Or you may not like using any label at all and proudly call yourself simply *a quilter.*

PRINCIPLES OF MODERN QUILTING

Let's suppose you want to make a patriotic quilt and add some modern design elements to it. How can you do that?

Let's start with the basic question: what makes a quilt modern? This is a question I often hear when talking with quilters I meet in local quilt shops and online, or when I make presentations to guilds. First, don't worry about the "modern quilt police" showing up to squint at your quilt. Modern quilting is a movement that is open and welcoming and, most of all, *fun!*

Modern quilt design principles are guidelines, NOT rigid rules! Freedom, individuality, fun and innovation are at the *heart* of modern quilting.

The basic principles of modern quilting are fairly straightforward. Modern quilting is a relatively new movement that has flexibility and innovation at its heart. Modern quilters build on and honor hundreds of years of quilting tradition. Then, modern quilters make adaptations and challenge rules to make their modern quilts uniquely their own.

There are some things to look for when you wonder what makes a quilt modern. You won't see **all** of these elements in a modern quilt, but the quilter usually uses at least one or two of these elements. This is a list of modern design elements to consider using when you decide to make a patriotic modern quilt. Look for just one or two or three that you want to emphasize. To see these principles in action, look at the beginning of each pattern and you will see a list of the modern design principles incorporated.

Modern design principles are:

- *Simplicity and minimalism*

- *Modern color palettes and bold, graphic prints*

- *Modern traditionalism:* reinterpretations of the past (using traditional blocks in a new way)

- *Asymmetry and alternate grid layouts*

- *Infinite edges:* no binding and no borders, or making the binding and borders from the background fabric

- *Use of negative space:* incorporating a background fabric that covers a noticeable percentage of the quilt top

- *Playing with scale:*

 – experimenting with block scale/size, such as one large block floating in a background of neutral space

 – repeating the same block in two or three different sizes in the quilt

- *Improvisation:* experimenting with block design, quilt layout, fabric choices and all other aspects of quilt design. Improvisation means seeing what emerges when you let go of pre-planning and measuring!

- *Maximalism:* an emerging trend in modern quilting characterized by use of saturated colors in all areas of the quilt, including negative space

QUILTS OF VALOR
I hope that you will use the patterns in this book to make a fresh, modern quilt for a service member, veteran or first responder.

If you are awarding your quilt to a veteran or active duty member of the U.S. Armed Forces, be sure to check out www.QOVF.org for more information on Quilts of Valor™.

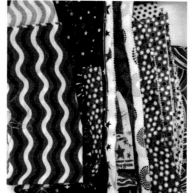

FINDING AND CHOOSING FABRICS FOR PATRIOTIC MODERN QUILTS

CHOOSING PATRIOTIC PRINTS

Patriotic prints are everywhere! Here's a look at some of the more modern prints that I use. Patriotic prints usually have very strong designs that can be balanced by using near solids or solids around them. You can use several print fabrics and mix them, as I have done in the improvisational blocks that you'll see in this book and on my blog.

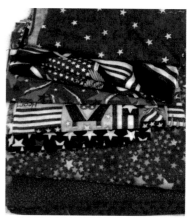

You'll notice that nearly all of the patriotic prints I use have white in them. These are easier to coordinate as you can see in the photos at right.

Look for white undertones or backgrounds in your patriotic prints

For a fresh, modern look, an easy option is to make sure your print fabrics coordinate well with the fabric you will use as the dominant neutral in your quilt. *Look for white undertones or backgrounds in your patriotic prints!* The most compatible *solids* that play well with patriotic prints will usually have white as a very subtle undertone. Check this by first looking at the wrong side of the fabric. For example, when I turned a red tone-on-tone fabric over to the wrong side, I could see that there was white faintly showing. From the right side, the white was not apparent. If you see the white undertone, then this fabric might be easiest to use in your patriotic modern quilt.

One note of caution: mixing fabrics that have a beige undertone with fabrics that have a white undertone may give you a quilt that has a disjointed appearance. Test and test again before cutting a lot of fabric to make sure that your selections are interesting and **cohesive** enough to achieve the effect you want.

Military-themed fabrics, for example, can work well in a patriotic quilt, but they are a bit trickier to use because many include beige or olive green. They will take some careful testing. Make a test block before committing yourself to cutting and sewing a lot of blocks and then finding out that the quilt isn't holding together as cohesively as you imagined.

Yellow and gold fabrics are great choices for modern patriotic quilts, especially if some of the other patriotic fabrics have a yellow or gold color in them.

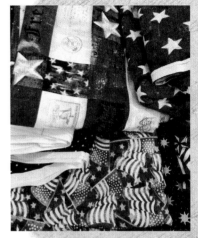

WHERE TO BUY MODERN PATRIOTIC FABRICS

Many fabrics go out of print, so you may not be able to find the exact prints you see in this book. Fortunately, manufacturers are coming out with new lines of fabric all the time. I buy my patriotic fabrics at local quilt shops and from online fabric stores. When searching for patriotic fabric, use keywords such as "4th of July," or look under the holiday-themed fabrics. Be creative when looking for fabrics. For example, I find most of the gold, red and blue tone-on-tone fabrics in "Christmas/Winter/Hanukkah" fabric groups rather than the "patriotic" one.

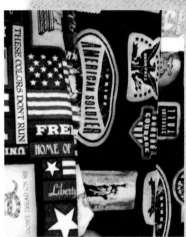

A WORD ABOUT BACKGROUND FABRIC

If you are new to modern quilting, the term "background fabric" might be unfamiliar. Some quilters think I mean the backing (the fabric that will go on the back side of the quilt), but that is *not* what "background fabric" means.

These are great fabrics, but use them sparingly as they have quite a bit of beige in them.

Background fabric refers to a fabric that will be used extensively in the quilt *top*. You will see that this is usually the largest single amount of fabric in the materials list.

In these projects, the background fabric covers a lot of the quilt surface. It is used in what we modern quilters call "negative space," or the areas of fabric or blocks that are not pieced or appliqued. It is open space perfect to set off your pieced blocks. It's also wonderful space for motif quilting.

The background fabric is the one that I often choose last. First, I choose the prints or solids for the project, and then I choose a background fabric to be sure that it complements the shades and tones in my other fabrics.

Using only plain solids for your background fabric might be a bit...well, *boring!*

There are ways to bring a lot of variety and interest to the background fabric used to create negative space in your project. I've discovered a wonderful world of "near solids"—subtly printed fabrics that give texture and movement to your quilts. Look for these at your local quilt shop when you plan your project.

Many fabrics fall under the category of "near solids." Look for tone-on-tone, mottled, marble or hand-dyed fabrics. Some examples:

• *Grunge™ by BasicGrey for Moda Fabrics:* In red, yellow or blue, these are some of my favorite fabrics to use instead of solids.

• *Ombré fabrics:* Using an ombré is an easy way to get several values of a color (light, medium and dark) that you know will all coordinate.

• *Subtle prints:* Some fabrics that have a very, very faint print over a solid or near-solid background—for example, a red solid overprinted with a very faint white crosshatch.

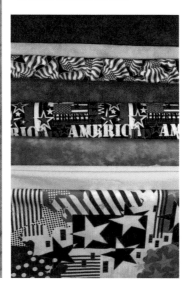

Light blue tone-on-tone.

In this assortment, I selected a mottled yellow, mottled red and mottled blues and paired them with a selection of patriotic prints.

Batiks provide one option for suitable background fabrics. Look for subtle batiks that will complement your patriotic prints. These will be clearer colors close to primary red and blue. Avoid batiks that have a greenish or beige undertone. If I'm using other prints, I usually avoid batiks that have a strong graphic design.

TESTING FOR COLORFASTNESS

I do not usually prewash my fabrics, but I do test them all to see if they will run or bleed, especially the deep blue and deep red fabrics.

To conduct this test, cut a swatch about 2" square and wrap it in a piece of very wet white paper towel. Let the fabric/paper towel bundle sit for at least 10 minutes before checking to see if the fabric runs. If it does, return it to the store immediately. In a humid climate, that dye could bleed when the quilt is stored or washed.

Some colors will bleed more than others, so it is worth testing beforehand.

In this photo, the red fabric bled but the two blue fabrics did not. In this case, I threw out the fabric because it was a couple years old and I didn't know where I'd purchased it.

If the fabric seems to bleed only a little, you could try setting or washing out the excess dye. Try washing the fabric with a product like ColorCatchers™ or Retayne™, following manufacturer instructions, and then test it again. If the fabric still bleeds, then throw it away or return the yardage to the shop for a refund. Please don't give it away; you don't want to give bad fabric to another quilter!

USING A DESIGN WALL

I recommend using a design wall of some type. It can be as simple as a piece of flannel or a flannel-backed tablecloth taped to a large wall. It is very difficult to see your overall design effect if the quilt is on the floor or too close to you, such as when it is lying on a bed.

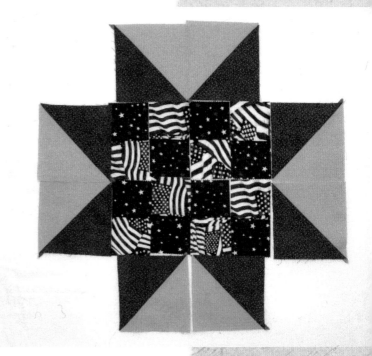

Take periodic photographs and print them out or look at them on your computer screen. When I do that, I often see new possibilities for rearranging blocks or adding more negative space, or other design choices that I just can't see when I'm too close to my quilt. I also sometimes see mistakes or a specific block that needs to be changed.

PRESSING

After I piece every seam, I lightly starch and press the block. I notice that my blocks lie flatter and I can match seams more easily. This is also a helpful habit when making improvisationally pieced blocks. Frequent ironing keeps the fabric from getting too wobbly when there are many bias edges. I use a light spray of Best Press™, and many of my friends use spray starch or similar products. Find what works best for you!

BINDINGS

I like making two types of bindings:

- *Faced Binding:* This is my "go-to" binding when I want a quilt to have an infinite edge. I particularly like Victoria Gertenbach's tutorial, available here: http://thesillyboodilly.blogspot.com/2012/09/tutorial-super-duper-easy-way-to-face.html.

- *Pieced Binding:* My pieced bindings have standard mitered corners. I sometimes make an "infinite edge" pieced binding by sewing together leftover fabrics from the quilt top. I always include plenty of the fabric that I used for the background in the binding. That way, the edge is infinite AND has a pop of color and pattern to delight the eye. I usually make binding strips that are 2½" wide, then double fold them, machine stitch them to the front, and hand stitch them down on the back.

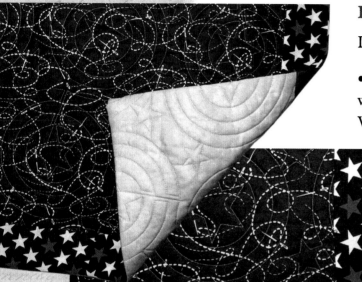

Faced binding

Pieced binding

QUILTING YOUR PATRIOTIC MODERN QUILT

Modern quilts need modern quilting! Although you may be tempted to stick to stars and eagles, I encourage you to experiment and explore new options. You can use straight-line or matchstick quilting or use free motion quilting or even ruler work for a more organic look. There are also many new modern programmed designs (pantographs) that can be used on a longarm. Fortunately, there are many, many great resources to teach you about modern quilting.

Here are just a few:

ON CRAFTSY.COM

Creative Quilting: Alternatives to Free Motion with Susan Cleveland

Creative Quilting with Your Walking Foot with Jacquie Gering

Next Steps with Your Walking Foot with Jacquie Gering

Start Free Motion Quilting with Elizabeth Dackson

ON IQUILT.COM

Machine Quilting on the Grid with Gina Perkes

Modern Simplicity Quilting Designs with Jodi Robinson

Successful Machine Quilting: Basics to Bobbins with Michele Scott

MODERN QUILTING BOOKS

Jacquie Gering, *WALK: Master Machine Quilting with Your Walking Foot*

Angela Walters, *Quilting Is My Therapy: Behind the Stitches with Angela Walters*

Susanne Woods, *Lucky Spool's Essential Guide to Modern Quilt Making: From Color to Quilting: 10 Design Workshops by Your Favorite Teachers*

Jacquie Gering and Katie Pedersen, *Quilting Modern: Techniques and Projects for Improvisational Quilts*

Tula Pink and Angela Walters, *Quilt with Tula and Angela: A Start-to-Finish Guide to Piecing and Quilting Using Color and Shape*

These recommendations are strictly *personal* —no remuneration or considerations were given for including them in my book. In other words, no one is paying me to suggest these resources!

America was not built on fear. America was built on *courage,* on imagination and an unbeatable determination to do the job at hand.

HARRY S. TRUMAN

TUTORIALS

MAKING HALF-SQUARE TRIANGLES (HSTs)

There are many methods for making half-square triangle units (also called HSTs). Instead of using templates, try this fast and easy method!

For each project, I suggest that you make a test HST following these instructions BEFORE cutting up all of your fabric. Read through all of the steps before you start. If you need additional instruction, you can find tutorials for this method and other methods all over the Internet.

CUTTING HSTs BASE SQUARES

Finished	Unfinished	Cut
3"	3½"	5"
4"	4½"	6"
5"	5½"	7"
6"	6½"	8"

1. Determine the size of your base square, making sure it's oversized. As a general rule, I start by cutting my base squares 2" larger than my desired finished size. See the cutting table at left. You'll refer to this table for all projects that have HSTs.

2. Cut two base squares from two different fabrics.

3. Placing the fabric right sides together, draw a diagonal line from one corner to the other. I use a regular number 2 pencil and draw very lightly, but you may use any type of marking tool you prefer.

4. Stitch on both sides of your drawn line using a ¼" seam.

5. Cut the base square in half on the drawn line. You will have two triangles.

6. Press the triangles open with seam allowances going towards the darker fabric. Press very lightly so the units don't stretch. Sometimes I give these triangle units a light spray of starch, Flatter™ or Best Press™ to keep them stable. Don't bother trimming those little dog ears off—you'll do all the trimming in the next step.

7. Trim the open squares to desired size using a square up ruler. I used blue tape to mark off the desired size on my ruler—in this example, I was making 3½" HSTs, so I put the blue tape there. Trim off the little dog ear (carefully) and position this corner on the ruler. Lay the diagonal line directly on the seam to help keep the HST even and square.

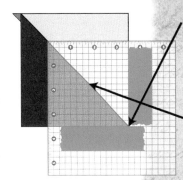

1 Trim the dog ear and line the square up with the desired size lines.

2 Line the seam up carefully with the diagonal line on the ruler.

You will have very little waste, and you'll save a lot of time because you will be making two at a time! Remember: mark off the desired size on your ruler so you won't accidentally trim to the wrong size.

TROUBLESHOOTING PROBLEMS

1. If your test HST is too small, then your ¼" seam allowance may be off. This will cause you to sew too far away from the drawn diagonal line in Step 3. Measure your seam allowance and adjust your machine accordingly. Another easy fix is to make your base square ½" larger.

2. Before you trim your base square, check the bottom left corner to make sure that it is square and that the center seam is on the diagonal line on your ruler.

Trimmed block and small leftovers. This method really has only a tiny bit of waste, which I think is worth it to get accurate HSTs. Keep the leftovers to use as improvisational elements in other projects!

TIPS FOR PAPER PIECING

The paper pieced blocks in this book are fairly simple, so even if you are new to paper piecing you should be able to piece these blocks quickly and easily.

Is this your first time making *paper-pieced blocks?*
I suggest you watch paper piecing tutorials or work with an experienced friend.
There are great tutorials and classes available online if you are very new to this technique.

Here are some general tips:

- Copy the paper-piecing templates at 100% on your copier. Always measure your copies to make sure that the size is accurate before you start making your blocks. I make a few extra copies so that I can make a couple of practice blocks BEFORE I cut out all my fabric for paper piecing.

- Use cheap white copy paper, marked 20 lb. weight. Heavy paper does not help you with paper piecing because it's much more difficult to remove.

- Cut out the templates on the DOTTED line. The solid lines are the stitching lines you will use to sew the fabric onto the template—be careful not to cut those! The dotted line around the outside of the template pieces is your normal ¼" seam allowance.

- Shorten your stitch length slightly. On my machine, I go from about a 2.1 (my normal stitch length) to 1.8. You want to make the stitches a bit smaller so the paper will be easy to rip away. Test this with some scrap paper and fabric to get a stitch length that makes it easy to remove the paper.

- ALWAYS press with a DRY iron. Steam will distort the paper and fabric.

- When I remove the paper, I first gently bend and crease the paper along the stitched seams. This makes it even easier to remove. If I have any stubborn pieces, I use my tweezers to gently pull them out.

- Test, test, test and practice! I suggest that you use scrap fabric and test making each section BEFORE cutting out all of your fabric.

MAKING FLYING GEESE BLOCKS

Be sure to read the "Tips for Paper Piecing" section.

There are many methods for making flying geese blocks. Most of these methods require precision measuring that can be a bit tricky or using templates or special rulers.

For the projects in this book, I have provided paper piecing templates that make quick and accurate work of flying geese blocks.

1. You will start with squares in two different sizes that you will cut in half on the diagonal. Check the Cutting Table for each project to see what size squares to start with.

After cutting the squares in half, you will need 2 triangles for the "wings" and one larger triangle for the center.

2. Place center triangle with the wrong side of the fabric against the wrong side of the paper piecing template. (You should be able to read the paper piecing letters.) **Note that the dark solid lines of the triangle will be your stitching lines.**

3. Place one of the "wing" triangles with the right side facing the right side of the center triangle. Stitch with a short stitch length along the solid line between D3 and D1, but sew from one edge of the template to the other.

Do not trim anything at this stage!

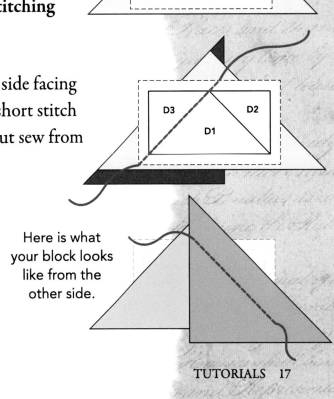

Here is what your block looks like from the other side.

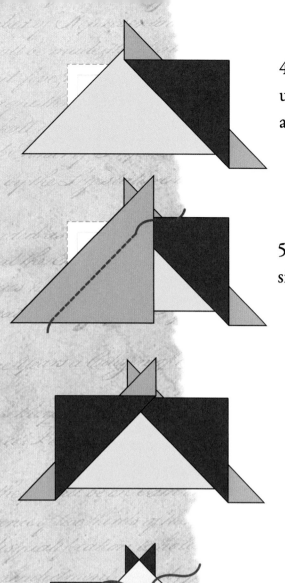

4. Fold back the "wing" and iron it into place. I recommend using a dry iron because steam might cause the ink to run and bleed onto your fabric. Do not starch!

5. Repeat with the 2nd wing. Place it right side facing right side. Stitch and press open.

6. Trim excess fabric to the seam allowance line of the template. The seam allowance is the dotted outside line.

I usually leave the papers in until after I piece the entire block. Leaving the papers in will give your blocks more stability as you handle them.

Before trimming

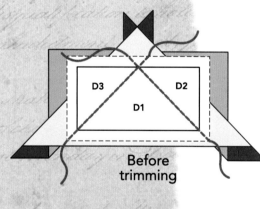

After trimming

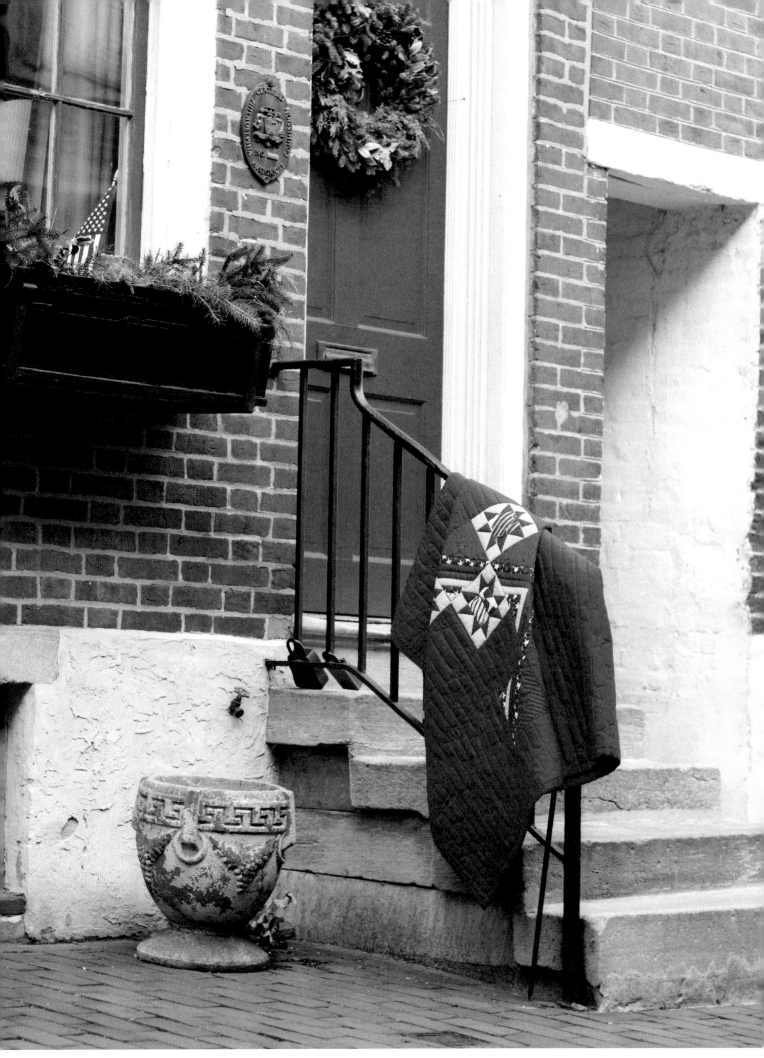

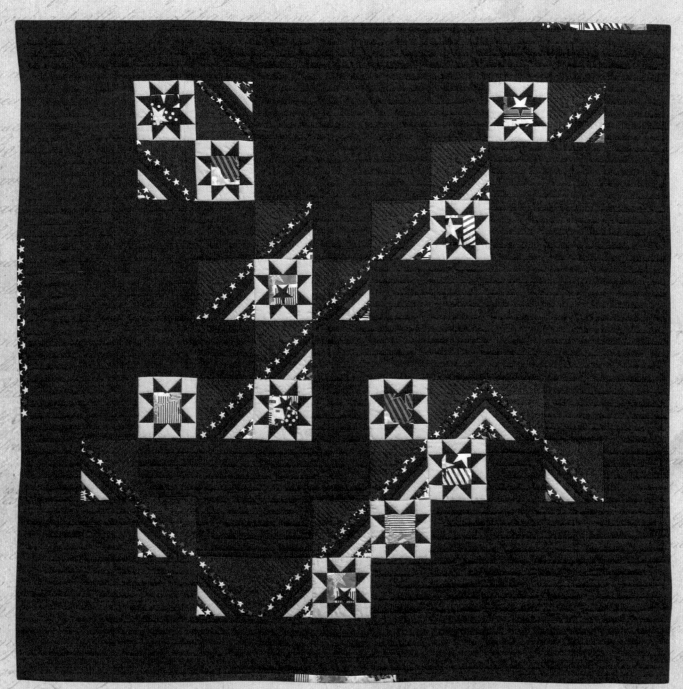

Strings & Stars

Preamble

We the People of the United States, in Order to form a more perfect Union, establish Justice, insure domestic Tranquility, provide for the common defence, promote the general Welfare, and secure the Blessings of Liberty to ourselves and our Posterity, do ordain and establish this Constitution for the United States of America.

FINISHED SIZES
66" x 72" lap quilt
42" x 54" crib quilt
20" x 44" table runner

DESIGNED BY
Carole Lyles Shaw

PIECED BY
Diane Sullo

QUILTED BY
Karlee Sandell

MATERIALS LIST FOR 66" X 72" LAP QUILT

You will need:

• 5 yards of solid #1 for background fabric and to use in star and strip blocks (solid blue in sample)

• 1 yard of solid #2 (solid red in sample)

• 1 yard of solid #3 (solid yellow in sample)

• 1 yard of patriotic print #1 (flag fabric in the sample)

• ½ yard of patriotic print #2 (blue with white stars in the sample)

INTRODUCTION

This quilt scatters stars and string-pieced blocks across the top. It can be made from a mix of solids and patriotic prints.

There are two machine paper-pieced blocks: a star block and a string block. The paper piecing is fairly simple because the pieces are all a good size—making it an ideal project for the quilter who is just starting to learn machine paper piecing. Instructions for a crib quilt and a table runner are included in this pattern on separate pages.

You will use these modern quilting design elements in this project:

Asymmetry *Alternate grid layout*
Modern traditionalism *Infinite edge binding*
Negative space

INSTRUCTIONS FOR LAP QUILT 66" X 72"

CUTTING QUILT BACKGROUND (SOLID #1)

Block sizes to cut	Number of blocks to cut	See Assembly Diagram (p. 25) for placement of these blocks using the numbers below
6½" x 6½"	8	2, 4, 8, 14, 15, 16, 18, 19
12½" x 6½"	5	6, 9, 10, 20, 22
18½" x 6½"	4	5, 7, 12, 21
24½" x 6½"	4	3, 11, 17, 23
30½" x 6½"	1	13
54½" x 6½"	1	1
60½" x 6½"	2	24, 25
66½" x 6½"	2	26, 27

When you cut the blocks, I suggest you pin a label on each stack showing what number it is—numbers are shown in the far right-hand column of the table above. That way, when you get ready to assemble the top, you won't get the sizes mixed up.

CUTTING STAR BLOCKS

If you are new to paper piecing, please read the tutorial sections "Tips for Paper Piecing" and "Paper Piecing Flying Geese." I suggest that you use scrap fabric and test making each section BEFORE cutting out all of your fabric.

Fabric	Star Patches	Size to cut	Quantity	
Solid #1 (blue in sample)	A2, A3, B2, B3, C2, C3, D2, D3	3" x 3"	44	Cut squares in half diagonally to make 88 triangles (8 per block)
Solid #3 (yellow in sample)	A4, A5, B4, B5	2½" x 2½"	44	4 squares per block
Solid #3 (yellow in sample)	A1, B1, C1, D1	4" x 4"	22	Cut squares in half diagonally to make 44 triangles (4 per block)
Patriotic print #1 (flag print in sample)	C4	4" x 4"	11	1 square per block

ASSEMBLY STAR BLOCKS

You will make 11 paper-pieced star blocks, each measuring 6½" square (unfinished).

Paper-piecing templates are provided on page 30. Match each fabric from the cutting table with its corresponding patch in the block. After printing the templates, you can cut apart the major sections for ease in piecing. Be SURE to cut on the dotted lines—this is your seam allowance.

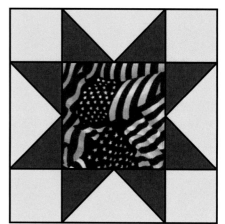

To assemble this block, read all instructions before starting:

1. Make four Flying Geese using template sections A1,2,3/B1,2,3/C1,2,3/D1,2,3. See the tutorials on "Tips for Paper Piecing" and "Paper Piecing Flying Geese" for instructions. Do NOT remove papers at this stage. Trim on seam allowances.

2. Paper piece sections A4 and A5 to Flying Geese block A1/A2/A3. Trim on seam allowances.

3. Paper piece sections B4 and B5 to Flying Geese block B1/B2/B3. Trim on seam allowances.

4. Piece Flying Geese Block C1/C2/C3 to C4. Add Flying Geese Block D1/D2/D3 to this section.

5. Add side blocks to right and left sides of this center section.

6. Remove all papers.

CUTTING STRING BLOCKS

If you are new to paper piecing, please read the tutorial section "Tips for Paper Piecing." I suggest that you use scrap fabric and test making each section BEFORE cutting out all of your fabric.

Fabric	String Patch	Size to cut	Quantity	
Solid #2 (red in sample)	A1	7½" x 7½"	10 squares	Cut squares in half diagonally to make 20 triangles*
Solid #2 (red in sample)	A4	1½" x 7"	19 strips	
Patriotic print #2 (stars in sample)	A2	1½" x 10"	19 strips	
Patriotic print #2 (stars in sample)	A6	1½" x 4"	19 strips	
Solid #1 (blue in sample)	A3	1½" x 9"	19 strips	
Solid #3 (yellow in sample)	A5	1½" x 5"	19 strips	
Patriotic print #1 (flag print in sample)	A7	2½" x 2½"	19 strips	

*You will have one left over.

ASSEMBLY STRING BLOCKS

You will make 19 paper-pieced string blocks, each measuring 6½" square (unfinished).

Paper-piecing templates are provided on page 31. Match each fabric from the cutting table with its corresponding patch in the block.

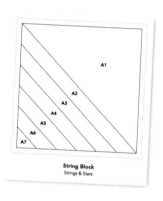

String Block
Strings & Stars

1. Place large red square (A1) right side up on **wrong** side of paper piecing template. Place first strip (A2) with right side facing the red square. Flip everything over and stitch on bold line on right side of template.

2. Iron first strip open and place second strip (A3) right side down on block. Flip block over and stitch.

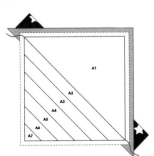

3. Continue placing strips and sewing.

Flip open A3 and add A4.

Flip open A4 and add A5.

Flip open A5 and add A6.

Flip open A6 and add A7.

Flip open A7.

4. After placing all strips, trim the block on the dotted seam allowance lines.

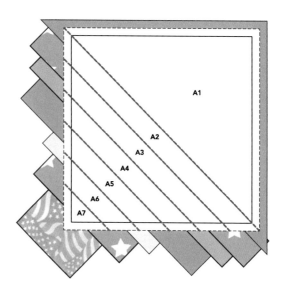

COMPLETING THE TOP

Follow the cutting table and assembly diagram to complete the top. See Finishing and Binding on page 29.

QUILT ASSEMBLY DIAGRAM: 66" X 72" QUILT

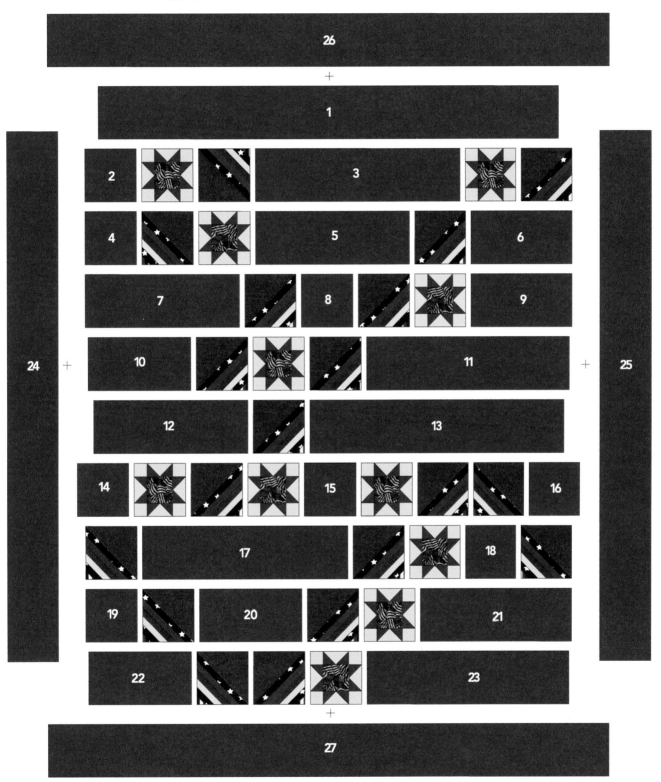

STRINGS & STARS: CRIB QUILT

Use the instructions for making the blocks as shown on the previous pages.

CUTTING QUILT BACKGROUND (SOLID #1)

Block sizes to cut	Quantity	See Quilt Assembly Diagram for placement of these blocks using the numbers below
6½" x 6½"	8	1
12½" x 6½"	5	2
18½" x 6½"	1	3
42½" x 6½"	2	4, 5

CUTTING STAR BLOCKS

You will make 6 star blocks for the crib quilt.

Fabric	Star Patches	Size to cut	Quantity	
Solid #1	A2, A3, B2, B3, C2, C3, D2, D3	3" x 3"	24	Cut squares in half diagonally to make 48 triangles (8 per block)
Solid #3	A4, A5, B4, B5	2½" x 2½"	24	4 squares per block
Solid #3	A1, B1, C1, D1	4" x 4"	12	Cut squares in half diagonally to make 24 triangles (8 per block)
Patriotic print #1	C4	4" x 4"	6	1 square per block

CUTTING STRING BLOCKS

You will make 8 string blocks for the crib quilt.

Fabric	String Patch	Size to cut	Quantity	
Solid #2	A1	7½" x 7½"	4 squares	Cut squares in half diagonally to make 8 triangles (1 per block)
Solid #2	A4	1½" x 7"	8 strips	
Patriotic print #2	A2	1½" x 10"	8 strips	
Patriotic print #2	A6	1½" x 4"	8 strips	
Solid #1	A3	1½" x 9"	8 strips	
Solid #3	A5	1½" x 5"	8 strips	
Patriotic print #1	A7	2½" x 2½"	8 strips	

QUILT ASSEMBLY DIAGRAM: 42" X 54" CRIB QUILT

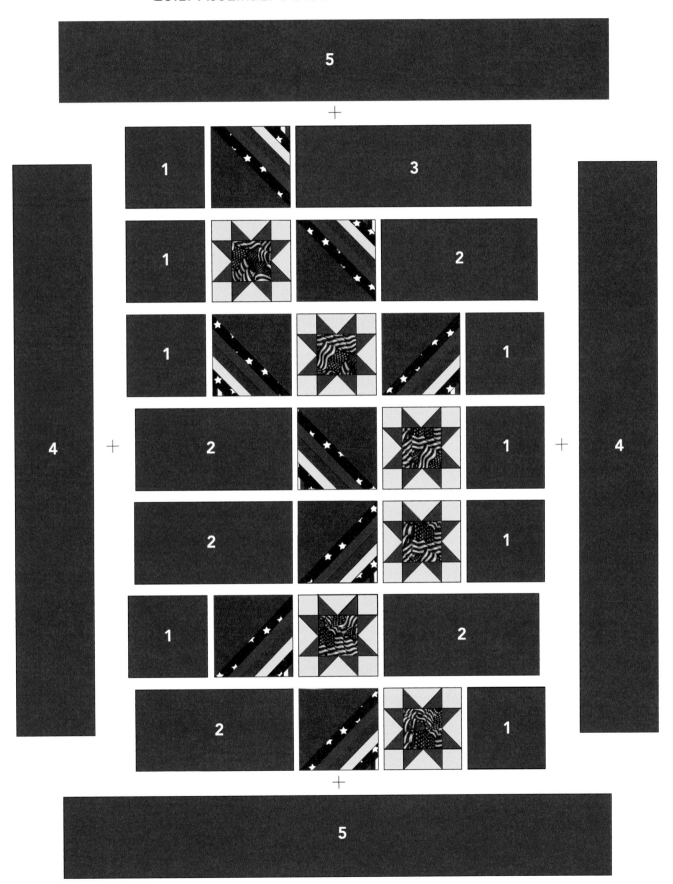

STRINGS & STARS: TABLE RUNNER

Use the instructions for making the blocks as shown on the previous pages.

CUTTING BACKGROUND BLOCKS

Block sizes to cut	Size to cut	Quantity	See Quilt Assembly Diagram for placement of these blocks using the numbers below
Solid #1	6½" x 6½"	3	1
Solid #1	3½" x 38½"	2	4
Solid #1	18½" x 6½"	2	5
Patriotic Print #2	1½" x 36½"	2	2
Patriotic Print #2	1½" x 14½"	2	3

CUTTING STAR BLOCKS

You will make 3 star blocks for the table runner.

Fabric	Star Patches	Size to cut	Quantity	
Solid #1	A2, A3, B2, B3, C2, C3, D2, D3	3" x 3"	12	Cut squares in half diagonally to make 24 triangles (8 per block)
Solid #3	A4, A5, B4,B5	2½" x 2½"	12	4 squares per block
Solid #3	A1, B1, C1,D1	4" x 4"	6	Cut squares in half diagonally to make 12 triangles (4 per block)
Patriotic print #1	C4	4" x 4"	3	1 square per block

CUTTING STRING BLOCKS

You will make 6 string blocks for the table runner.

Fabric	String Patch	Size to cut	Quantity	
Solid #2	A1	7½" x 7½"	3 squares	Cut squares in half diagonally to make 6 triangles (1 per block)
Solid #2	A4	1½" x 7"	6 strips	
Patriotic print #2	A2	1½" x 10"	6 strips	
Patriotic print #2	A6	1½" x 4"	6 strips	
Solid #1	A3	1½" x 9"	6 strips	
Solid #3	A5	1½" x 5"	6 strips	
Patriotic print #1	A7	2½" x 2½"	6 strips	

MATERIALS LIST FOR 20" X 44" TABLE RUNNER

You will need:

• 1½ yards of solid #1 for background fabric (solid blue in sample)

• ¼ yard of solid #2 (solid red in sample)

• ⅜ yard of solid #3 (solid yellow in sample)

• ¼ yard of patriotic print #1 (flag fabric in the sample)

• ⅜ yard of patriotic print #2 (blue with white stars in the sample)

QUILT ASSEMBLY DIAGRAM: 20" X 44" TABLE RUNNER

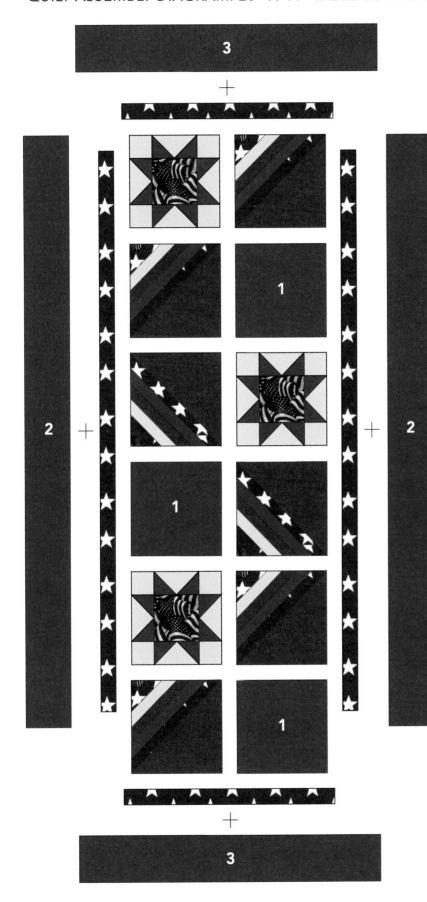

FINISHING AND BINDING ALL SIZES

BACKING AND BATTING

Measure your quilt top and cut or piece your backing and batting to size allowing for at least 3 inches extra on all sides. (Check with your longarm quilter for other backing and batting size requirements.) For a modern look, you can piece your backing using leftover fabric from the top, along with other coordinating fabrics in your stash.

LAYERING AND BASTING

Layer the quilt top, batting and backing. Baste as desired.

QUILTING

Use your preferred method. For more information and references on quilting techniques, see "Quilting Your Modern Patriotic Quilt" on page 11.

BINDING

Bind the quilt using your preferred style. For more information and resources on binding techniques, see "Bindings" on page 10.

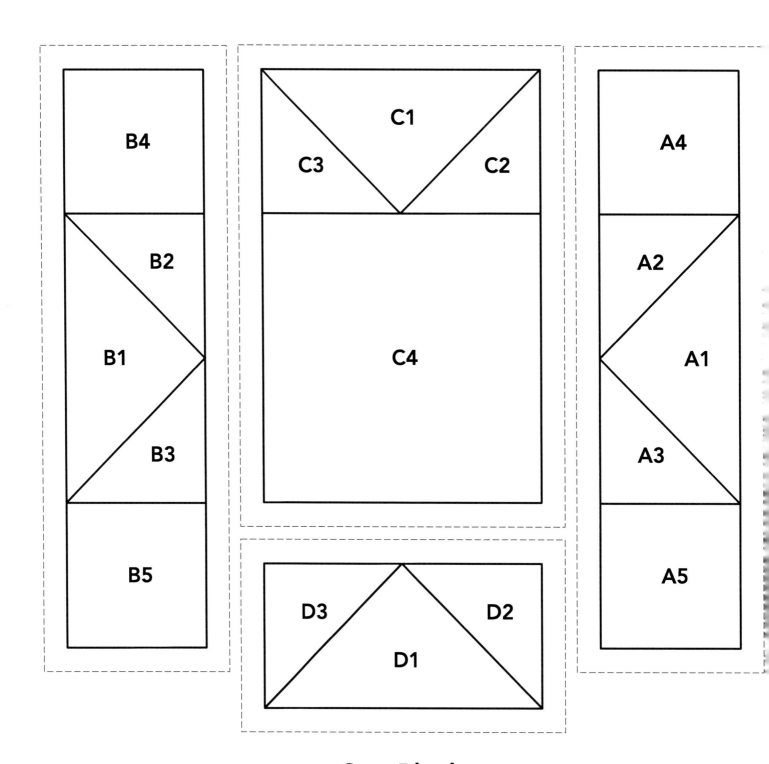

Star Block

Strings & Stars

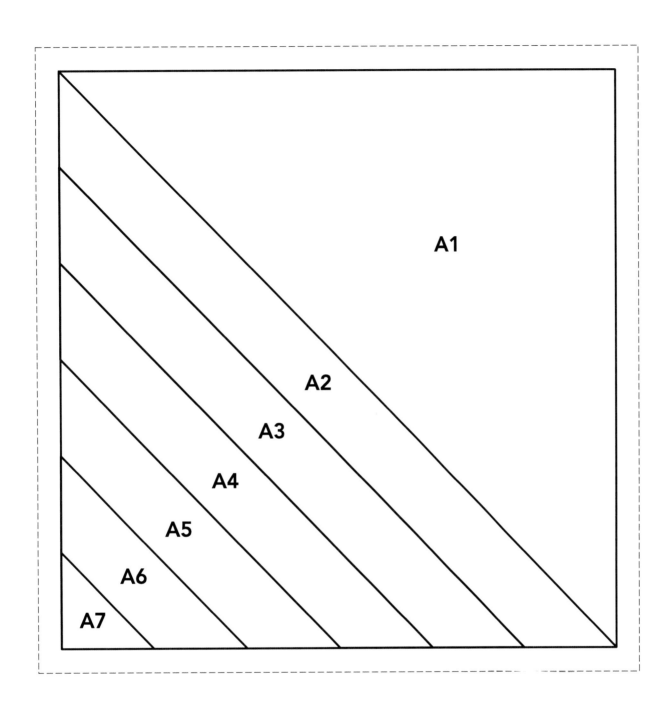

String Block

Strings & Stars

Star with Diamonds

Declaration of Independence Article 1

LEGISLATIVE

Section 1. All legislative Powers herein granted shall be vested in a Congress of the United States, which shall consist of a Senate and House of Representatives.

FINISHED SIZE
68" x 74"

DESIGNED BY
Carole Lyles Shaw

PIECED BY
Roxanne Kermidas
and Carole Lyles
Shaw

QUILTED BY
Karlee Sandell

MATERIALS LIST

You will need:

• 4⅝ yards of solid #1 for background fabric, half-square-triangle units and binding (blue in the sample)

• ¾ yard of solid #2 for half-square-triangle units (red in sample)

• ¾ yard of solid #3 for four-patch units (yellow in sample)

• ¾ yard of patriotic print fabric for four-patch units (red, white and blue print in sample)

Star with DIAMONDS

INTRODUCTION

This pattern is based on one base block rotated to achieve secondary effects. In the sample quilt shown here, I chose to create a star (upper left) and two diamonds (middle and lower right). Quick piecing instructions are included for making the half-square-triangle blocks and the four-patch blocks.

You will use these modern quilting design elements in this project:

Modern traditionalism (this quilt is my version of the Road to California traditional block)
Negative space
Alternate grid layout (rearranging the block can create interesting variations)
Infinite edge (faced binding)

FOUR-PATCH UNIT ASSEMBLY

You will make 55 four-patch blocks measuring 4½" x 4½" (unfinished).

You can strip piece the four-patch units quickly and easily. I recommend spray starching your strips to keep the distortion to a minimum. As you make the units, press with a dry iron to prevent stretching or shrinking.

1. From the patriotic print, cut 1 strip measuring 2½" by 40". From solid #3 (yellow), cut 1 strip measuring 2½" by 40".

2. Sew the two strips together. Gently press open, being careful not to distort them.

3. Cut the long strip pair in half as shown below. Layer the two halves **right** sides together so that the fabrics are opposite each other.

4. Cut the layered strips into pairs at 2½" intervals crosswise. Keep the pairs together.

 + +

5. Carefully sew the pairs together and press open.

6. Repeat Steps 1–4 until you have 55 four-patch units.

HALF-SQUARE TRIANGLE BLOCK ASSEMBLY

Make 44 half-square-triangle blocks measuring 4½" x 4½" (unfinished). For instructions, see "Making Half-Square Triangles" on page 14.

BASE BLOCK ASSEMBLY

All base blocks are pieced using this layout with the red/blue half-square triangles oriented as shown.

You will make 11 base blocks using 4 half-square-triangle units and 5 four-patch units.

I recommend using a design wall and making one base block at a time. Then put the completed base blocks on the design wall following the Quilt Assembly Diagram on page 35. Using a design wall is important; it is very easy to mix up the layout, which might spoil the secondary effect.

CUTTING
BACKGROUND AND BORDER FABRIC

From solid #1 (blue in sample), cut the blocks below. I suggest that you complete the pieced sections and measure them BEFORE cutting border blocks I, J and K.

Block sizes to cut	Number of blocks to cut from Solid #1	See Assembly Diagram for placement
12½" x 36½"	2	A, B
12½" x 12½"	4	C, E, F, H
12½" x 24½"	2	D, G
6½" x 60½"*	1	I
8½" x 60½"*	1	J
8½" x 74½"*	1	K

*You will piece Borders I, J and K from two strips of fabric because they are longer than the width of fabric.

COMPLETING THE TOP

Follow the quilt assembly diagram to complete the top. For alternative layouts, use your design wall! You can play with rotating the base blocks or shifting the placement for your background blocks A–H. Take photos along the way and decide which layout you prefer.

FINISHING AND BINDING

BACKING AND BATTING

Measure your quilt top and cut or piece your backing and batting to size allowing for at least 3 inches extra on all sides. (Check with your longarm quilter for other backing and batting size requirements.)

For a modern look, you can piece your backing using leftover fabric from the top, along with other coordinating fabrics in your stash.

LAYERING AND BASTING

Layer the quilt top, batting and backing. Baste as desired.

QUILT ASSEMBLY DIAGRAM: 68" X 74"

QUILTING

Use your preferred method. For more information and references on quilting techniques, see "Quilting Your Modern Patriotic Quilt" on page 11.

BINDING

Bind the quilt using your preferred style. For more information and resources on binding techniques, see "Bindings" on page 10.

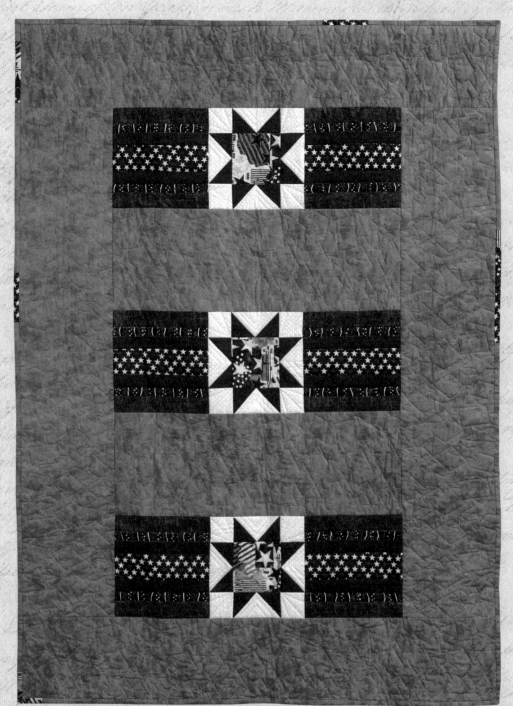

Strips & Stars #1

Declaration of Independence Article 2

EXECUTIVE

Section 1. 1: The executive Power shall be vested in a President of the United States of America... 8: Before he enter on the Execution of his Office, he shall take the following Oath or Affirmation:—"I do solemnly swear (or affirm) that I will faithfully execute the Office of President of the United States, and will to the best of my Ability, preserve, protect and defend the Constitution of the United States."

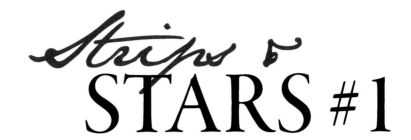

STRIPS & STARS #1

FINISHED SIZE
60" x 80" lap quilt
table runner
placemat

DESIGNED BY
Carole Lyles Shaw

**PIECED AND
QUILTED BY**
Carol Byrnes

MATERIALS LIST

You will need:

• ¼ yard (cut as yardage, not a fat quarter) of focus patriotic print #1 (Fabric #1)

• ½ yard of white solid or tone-on-tone print (Fabric #2)

• ½ yard of dark blue solid (Fabric #3)

• 4 yards of light blue solid or near solid (Fabric #4)

• ⅜ yard of red solid or tone-on-tone print (Fabric #5)

• ½ yard of focus patriotic print #2 (Fabric #6)

• ¼ yard (cut as yardage, not a fat quarter) of stripe or geometric print #2 (Fabric #6)

INTRODUCTION

This quilt is a modern take on two traditional blocks: 8 point star and rail fence block. I floated the pieced blocks in lots of negative space for a fresh, contemporary look. I've also added instructions to make a table runner and a placemat with these blocks.

You will use these modern quilting design elements in this project:

Modern traditionalism
Infinite edge binding (pieced)
Simplicity
Use of negative space

INSTRUCTIONS FOR LAP QUILT

CUTTING BACKGROUND BLOCKS

Block sizes to cut	Number of blocks to cut from Fabric #4	See Assembly Diagram (p. 39) for placement of these blocks using the letters below
10½" x 60½"*	2	A, F
12½" x 60½"*	2	B, E
12½" x 36½"*	2	C, D

* Long sections can be pieced.

TIP: *I usually cut these sections AFTER I piece the Star/Strip block rows. That way, if my piecing or other measurements are a bit off, I can adjust the length of these sections accordingly. I have saved myself a lot of time (and fabric) by cutting these sections last.*

CUTTING STAR BLOCKS—FLYING GEESE UNITS (3½" X 6½" UNFINISHED SIZE)

Fabric	Flying Geese Patch	Size to cut	Quantity	Subcut	Total pieces
Fabric #2 (white solid or tone-on-tone)	B	6" x 6"	6	Diagonally	12
Fabric #3 (dark blue solid)	C	5" x 5"	12	Diagonally	24

You will paper piece the flying geese units using the template provided on page 41. New to paper piecing? Read the tutorial sections "Tips for Paper Piecing" and "Paper Piecing Flying Geese" on pages 16–18 BEFORE cutting your fabric.

CUTTING STAR BLOCKS—CORNERS

Fabric	Star Block Patch	Size to cut	Quantity
Fabric #2 (white solid or tone-on-tone)	A	3½" x 3½"	12
Fabric #6 (focus patriotic print #2)	D	6½" x 6½"	3

ASSEMBLY STAR BLOCKS

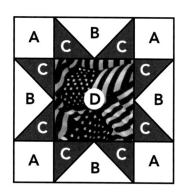

You will make 3 star blocks measuring 12½" x 12½" (unfinished).

The flying geese sections will be paper pieced using the template on page 41—this is an easy method of making flying geese that eliminates worrying about cutting off those triangle tips. New to paper piecing? See tutorial sections "Tips for Paper Piecing" and "Paper Piecing Flying Geese" on pages 16–18 BEFORE cutting your fabric. I also suggest that you practice with scrap fabric first.

1. Assemble the star block in this order:
 - Top Row: patch A; flying geese unit (B/C); patch A
 - Middle Row: flying geese unit (B/C); patch D; flying geese unit (B/C)
 - Bottom Row: patch A; flying geese unit (B/C); patch A
2. Piece all three rows together to finish the star.

CUTTING STRIP BLOCKS

Fabric	Strips	Size to cut	Quantity
Fabric #5	Strips A1, A2	2½" x WOF	4
Fabric #6	Strips B1, B2	1½" x WOF	4
Fabric #7	Strips C1, C2	1½" x WOF	4
Fabric #1	Strip D	2½" x WOF	2

ASSEMBLY STRIP BLOCKS

You will make 6 strip blocks measuring 12½" x 12½" (unfinished).

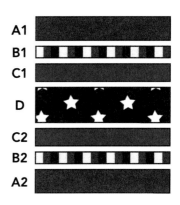

1. Starch fabric strips lightly to prevent them from distorting. These strips will measure approximately 40" long.

2. Piece the 7 layers together into a "strata" following the block assembly diagram shown at right.

3. Sub-cut the strata into 12½"-wide blocks. You should have 3 blocks measuring 12½" x 12½" with a tiny bit left over.

4. Repeat steps 1–3 above to create 6 blocks total.

COMPLETING THE TOP

Follow the Assembly Diagram to complete the top.

1. Assemble 3 rows. Each row has one pieced star block in the middle and two strip blocks.

2. Piece these rows with background rows C and D.

3. Sew the B & E background blocks to the left and right sides of the quilt top.

4. Sew the A and F borders on the top and bottom of the quilt top.

QUILT ASSEMBLY DIAGRAM: 60" X 80"

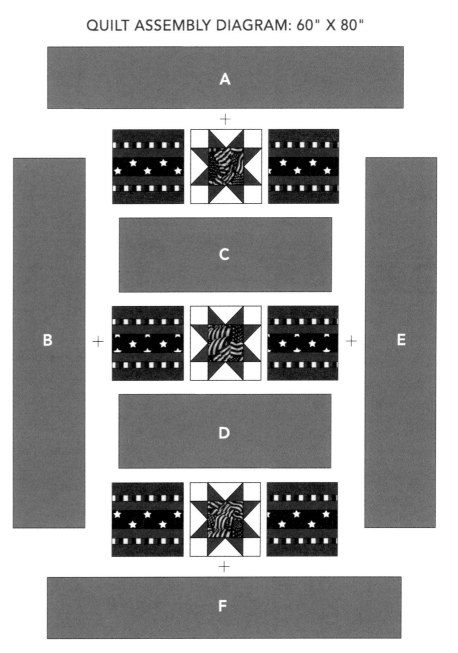

FINISHING AND BINDING

BACKING AND BATTING

Measure your quilt top and cut or piece your backing and batting to size allowing for at least 3 inches extra on all sides. (Check with your longarm quilter for other backing and batting size requirements.) For a modern look, you can piece your backing using leftover fabric from the top, along with other coordinating fabrics in your stash.

LAYERING AND BASTING

Layer the quilt top, batting and backing. Baste as desired.

QUILTING

Use your preferred method. For more information and references on quilting techniques, see "Quilting Your Modern Patriotic Quilt" on page 11.

BINDING

Bind the quilt using your preferred style. For more information and resources on binding techniques, see "Bindings" on page 10.

STRIPS & STARS #1: PLACEMAT & TABLE RUNNER

You can make a table runner or placemats using these blocks.

A placemat design might look like this. This 14" x 18" placemat was made with one Star block with 3" (finished size) borders and a striped binding.

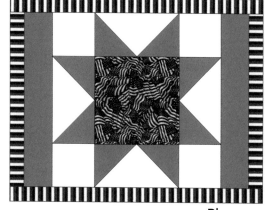

Placemat

A table runner design might be to make 1 Star Block and 2 Strip Blocks using the directions in this pattern and then adding a 2" (finished size) sashing and two borders. You can easily design a layout that fits the length and width of your table.

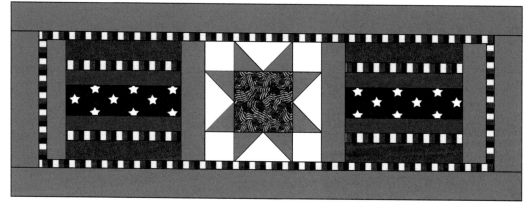

Table runner

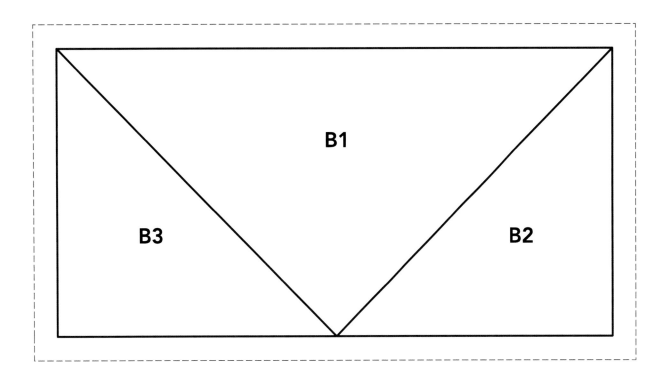

Flying Geese Block
Strips and Stars #1

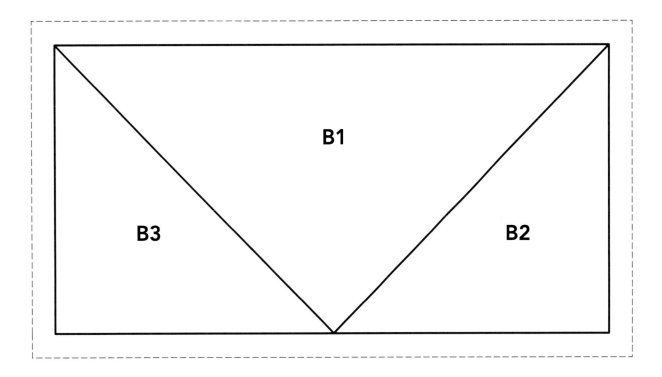

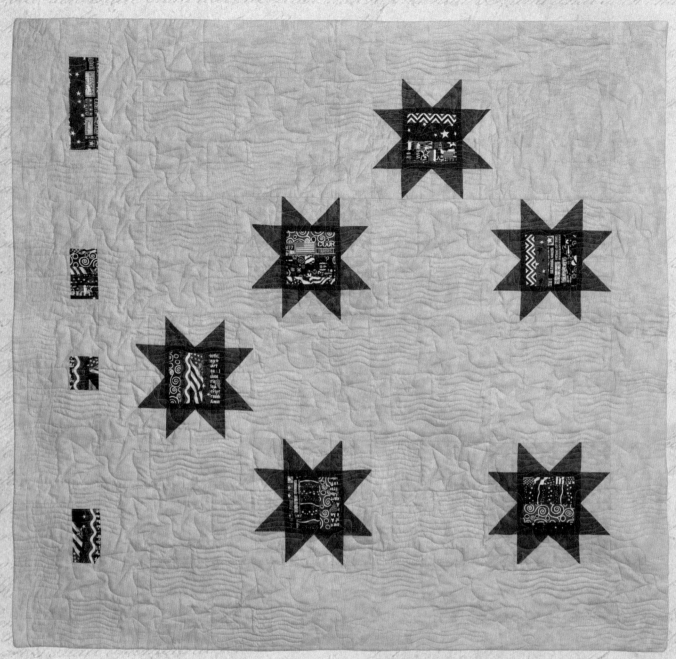

Strips & Stars #2

Declaration of Independence Article 3

JUDICIAL

Section 1. The judicial Power of the United States, shall be vested in one supreme Court, and in such inferior Courts as the Congress may from time to time ordain and establish. The Judges, both of the supreme and inferior Courts, shall hold their Offices during good Behaviour, and shall, at stated Times, receive for their Services, a Compensation, which shall not be diminished during their Continuance in Office.

FINISHED SIZE
65" x 72" lap size
Plus instructions for
making 91" x 110"
full size

DESIGNED BY
Carole Lyles Shaw

PIECED BY
Carole Lyles Shaw

QUILTED BY
Rose Ryan

MATERIALS LIST FOR LAP SIZE

I have listed some fabrics as solids but you can always substitute a tone-on-tone.

You will need:

• 5½ yards of gray solid (This is your background fabric.)

• ½ yard of red solid

• ¼ yard of yellow solid

• 1 strip, 8" x 27" of blue solid

• 1 fat eighth each of 6 patriotic prints, cut into strips measuring 1½" x 5½" for star centers (You will have leftovers for the pieced border.)

• OPTIONAL STAR CENTER: If you decide to use a focus fabric instead of piecing the centers, you will need one fat quarter of one focus fabric.

Strips & STARS #2

INTRODUCTION

This quilt is a lot of fun to make because you can arrange the star blocks any way you like! The star points are all made with half-square-triangle blocks and I've given you an easy way to make them.

You will use these modern quilting design elements in this project:

Asymmetry
Modern traditionalism
Negative space
Alternate grid layout
Infinite edges (faced binding)

CUTTING BACKGROUND SOLID SQUARES

Cut 10 squares from background fabric, each measuring 12½" x 12½".

ASSEMBLY STAR BLOCKS

You will make six star blocks for this quilt. In my sample quilt, I used a yellow fabric in two of the star blocks for punch. The other four stars seem to float because I used the gray background fabric in the star block in patches A and B.

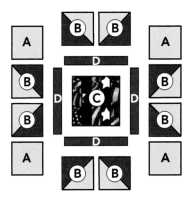

For each star block, you will need:

• 4 squares, 3½" x 3½", from the gray or yellow solid (patch A)
• 8 half-square-triangle blocks from the red and gray or yellow solids, 3½" x 3½" (patch B); see "Making Half-Square Triangles" on page 14 for instructions
• 1 pieced square measuring 5½" for the star center (patch C)
• 4 blue strips for the star center (D):
 – 2 strips measuring 6½" x 1"
 – 2 strips measuring 5½" x 1"

PIECING THE STAR CENTER

1. Piece the strips together and trim to 5½" x 5½". Make 6. Piece strips randomly so the star centers have variation in them.

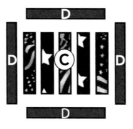

2. Sew the blue 5½" strips onto the left and right sides of each C center.

3. Sew the blue 6½" strips onto the top and bottom of each C center.

Complete the Star by sewing the A and B blocks to the completed center.

ASSEMBLY LEFT BORDER D

The middle left border (Border D in Assembly Diagram) is improvisationally pieced.

First, use print fabric "leftovers" from piecing the star centers and piece four sections.
Pieced sections measure:

- 3½" x 8½"
- 3½" x 5½"
- 3½" x 2½"
- 3½" x 3½"

Sew the pieced sections to background fabric pieces measuring 3½" wide by length needed until Border D is 3½" x 72½" long. You can space these sections improvisationally.

CUTTING BORDERS A, B C, E, F

Cut borders from background fabric. See Quilt Assembly Diagram for placement.

Piece name	Size to cut
Top border A	8½" x 48½"
Bottom border B	16½" x 48½"
Left border C and E	4½" x 72½"
Right Border F	6½" x 72½"

COMPLETING THE TOP

Using the Quilt Assembly Diagram at right, arrange solid squares and star blocks into rows. You can use the suggested layout here or play with rearranging the blocks.

Then add borders. Start with Borders A and B (top and bottom), then add the remaining borders.

FINISHING AND BINDING

BACKING AND BATTING

Measure your quilt top and cut or piece your backing and batting to size allowing for at least 3 inches extra on all sides. (Check with your long arm quilter for other requirements.) For a modern look, you can piece your backing using leftover fabric from the top, along with other coordinating fabrics in your stash.

LAYERING AND BASTING

Layer the quilt top, batting and backing. Baste as desired.

QUILTING

Use your preferred method. For more information and references on quilting techniques, see "Quilting Your Modern Patriotic Quilt" on page 11.

BINDING

Using leftover gray solid (or other fabrics), bind the quilt using your preferred style. For more information and resources on binding techniques, see "Bindings" on page 10.

QUILT ASSEMBLY DIAGRAM: 65" X 72" LAP SIZE

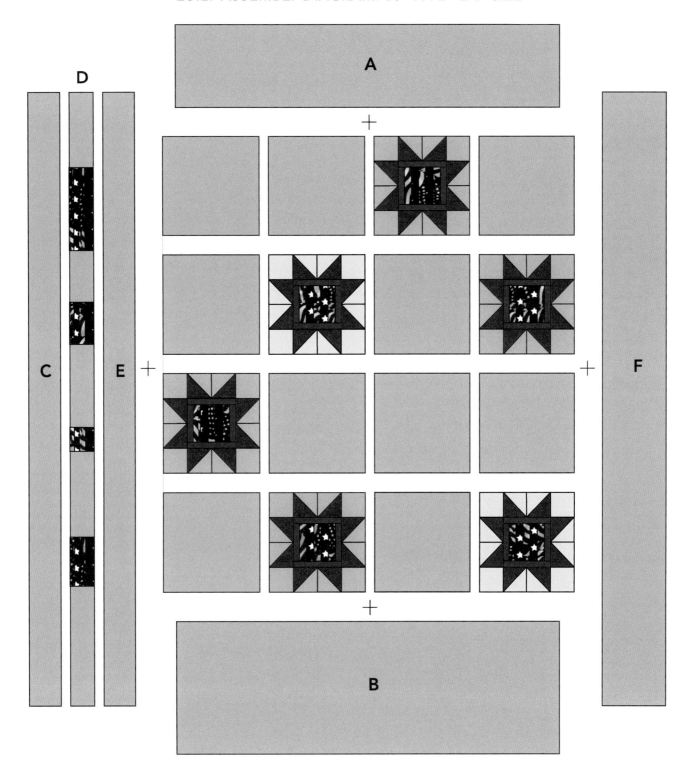

STRIPS & STARS #2: FULL SIZE

Here is an alternate layout for a quilt measuring 91" x 110" with fabric yardage needed. The Star Blocks are made with the same measurements shown for the smaller size quilt. Materials you will need:

- 7½ yards of gray solid
- 1 yard of red solid
- ½ yard of yellow solid
- ¾ yard of blue solid
- ⅜ yard each of six patriotic prints, cut into strips measuring 1½" x 5½" for star centers
- OPTIONAL STAR CENTER: If you decide to use one focus fabric instead of piecing the centers, you will need ¾ yard of the focus fabric.

CUTTING SOLID SQUARES

Cut 26 squares from the background fabric, each measuring 12½" x 12½".

ASSEMBLY STAR BLOCKS

You will make 16 star blocks for this size quilt. Follow instructions for the lap quilt on pages 43–44.

ASSEMBLY LEFT BORDER D

The middle left border (Border D in Assembly Diagram) is improvisationally pieced.

I cut gray fabric into random sizes 3½" wide. I then used "leftovers" from piecing the star centers and pieced four sections. You can piece them in any lengths that you like.

Pieced sections measure:

- 3½" x 15½"
- 3½" x 7½"
- 3½" x 10½"
- 3½" x 6½"
- 3½" x 11½"

Sew the pieced sections together with background fabric pieces so that the border is 3½" wide by 110½" long. You can space all of these sections improvisationally to achieve the look that you desire.

CUTTING BORDERS A, B C, E AND F

Piece the remaining borders from your background fabric. See Quilt Assembly Diagram for placement.

Piece name	Size to cut
Top border A	10½" x 72½"
Bottom border B	16½" x 72½"
Left border C and E	4½" x 110½"
Right border F	8½" x 110½"

FINISHING AND BINDING

See instructions on page 44 for Finishing and Binding.

QUILT ASSEMBLY DIAGRAM: 91" X 110" FULL SIZE

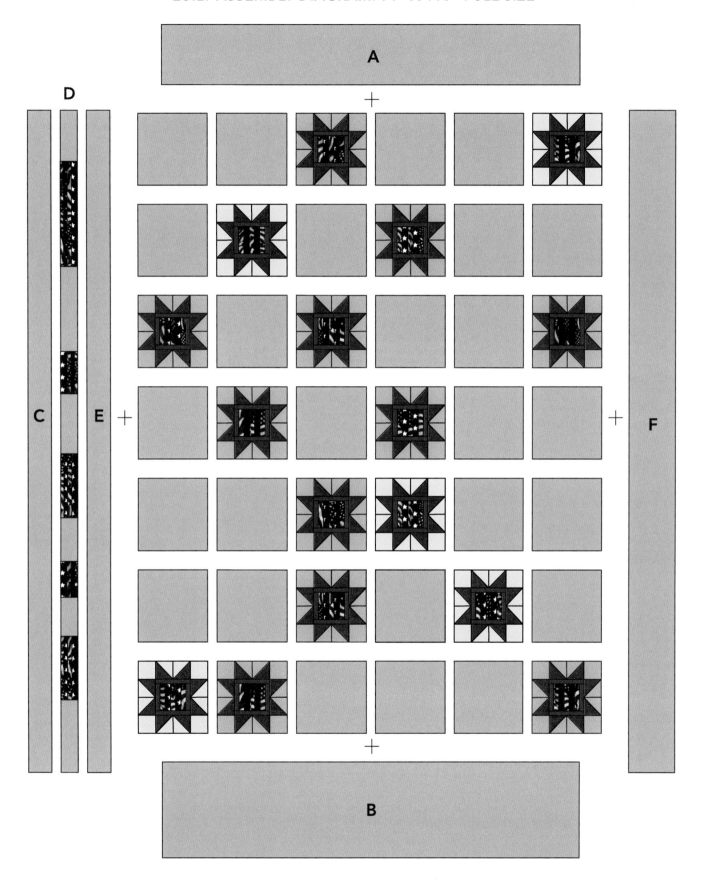

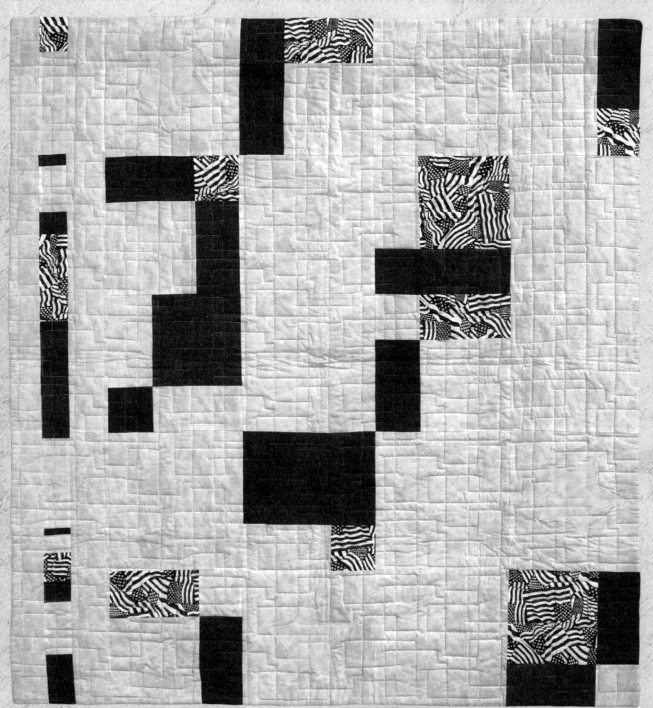

Disappearing Four Patch with Stars

Declaration of Independence Article 6

NATIONAL SUPREMACY

Section 2. This Constitution, and the Laws of the United States which shall be made in Pursuance thereof; and all Treaties made, or which shall be made, under the Authority of the United States, shall be the supreme Law of the Land; and the Judges in every State shall be bound thereby, any Thing in the Constitution or Laws of any State to the Contrary notwithstanding.

FINISHED SIZE
64" x 80"

DESIGNED BY
Carole Lyles Shaw

PIECED BY
Carole Lyles Shaw

QUILTED BY
Rose Ryan

MATERIALS LIST

You will need:

• 4¾ yards of gray solid (background fabric)

• ¾ yard each of deep yellow or gold, dark blue and deep red solid or tone-on-tone

• ¾ yard bold patriotic print

• Freezer paper

• Fusible interfacing such as Pellon 805™ or MistyFuse™ (optional)

• Washable glue stick or Glue Baste-It™ (optional)

Disappearing FOUR PATCH WITH STARS

INTRODUCTION

This pattern has been modified from the sample quilt shown so that it fits the Quilts of Valor™ Foundation size requirements. The changes are simple and can be used to "upsize" the quilt to any size desired. The changes made to my sample quilt are:

• Adding a top, right and bottom border

• Adding an additional row of blocks so that layout is 6 blocks down by 4 blocks across

• Adding a binding

You will use these modern quilting design elements in this project:

Asymmetry (scattering the stars in a random fashion)
Negative space
Modern traditionalism (altering the dimensions of a traditional Four Patch block)
Improvisation (creating an improvised border with scraps)
Infinite edges (faced binding)

FABRIC SELECTION TIPS

The key is to start by choosing a vibrant focus fabric. In this sample quilt, I used a flag-patterned fabric.

After you select your focus fabric, select red, dark blue and gold fabrics. They could be solids, tone-on-tone, subtle mottled or subtle batiks that contrast nicely with the focus fabric. The stars can be made from a gold batik or other solid or near solid.

To make the quilt modern, it is important to use a contrasting neutral for your background fabric. Instead of the gray shown, you can choose a pale blue, or even a tone-on-tone white.

CUTTING

Use the table below to cut your pieces.

Fabric	4½" x 4½" squares	4½" x 8½" rectangles	8½" x 8½" squares	12½" x 12½" squares	10" x 10" squares (used to make gold stars)
Flag print	4	4	2	—	—
Red print	1	5	2	—	—
Blue print	3	7	1	—	—
Gray solid	3	6	6	13	—
Gold print	—	—	—	—	3

ASSEMBLY FOUR PATCH BLOCKS

You will make a total of 11 Four Patch blocks. Each Four Patch block is created from two 4 ½" x 8 ½" rectangles of different fabrics, one 4½" x 4½" square and one 8½" x 8½" square.

4½" x 4½"	4½" x 8½"
4½" x 8½"	8½" x 8½"

When you piece the blocks, you can follow the color choices shown in the sample or make changes according to your own preference. However, be sure to follow the block layout as shown when you place the four pieces. Here are 6 options for placing the fabrics. But you can use your own imagination! Just make sure all blocks use the same layout.

APPLIQUÉING THE STARS

For these appliqué blocks, use the star template on page 52.

OPTION 1: FUSE AND MACHINE APPLIQUÉ

1. Cut 3 squares, 10" x 10", from a piece of Pellon 805™ fusible interfacing. Leave the paper on.

2. Iron the interfacing squares to the **wrong** side of the 10" x 10" squares of gold fabric.

3. Trace the star template onto dull side of 3 pieces of freezer paper. Do not add a seam allowance.

4. Iron the freezer paper star onto the right side of a yellow/gold fabric square.

5. Cut out the stars using very sharp scissors and gently remove the freezer paper.

6. Remove the interfacing paper from the wrong side.

7. Fuse each star onto the center of a 12½" x 12½" gray square.

8. Machine stitch along the outside edge of each star using a zigzag or blanket stitch (your choice). If you have another preferred machine appliqué stitch, use it! I machine stitch the star onto the square before putting these squares into the quilt. In the sample quilt I used a matching thread, but you could use a contrasting color for a more folk-art look.

OPTION 2: HAND APPLIQUÉ

1. Trace the star template onto the dull side of a piece of freezer paper, *adding a ¼" seam allowance to the outside of the template.*

2. Iron the freezer paper to right side of gold fabric.

3. Cut out the stars.

4. Using a pin or washable glue, attach the star onto a 12½" x 12½" gray square.

5. Remove freezer paper. Hand (needle turn) appliqué the star onto the gray square.

ASSEMBLY QUILT CENTER

1. Lay out the blocks, alternating the solid gray blocks and star blocks with the Four Patch blocks. You can follow my assembly diagram or create one of your own. Play with your layout until it pleases you.

2. Sew the blocks together into rows with 4 blocks across in each row.

3. Sew the rows together to make a quilt center with 6 rows of 4 blocks each.

ASSEMBLY STRIP-PIECED BORDER

1. Measure the pieced center from top to bottom. It should measure 72½" long. Create two strips each 3½" x 72½" (or length of pieced center) from the solid gray fabric. These are Borders A and B in the Assembly Diagram.

2. To make Border C, cut random-sized pieces from all of your fabrics, including the gray background fabric, each 2½" wide and between 2½" and 4½" long. Randomly select and sew the pieces together to form a strip 2½" x 72½" long. This is Border C in the Quilt Assembly Diagram.

3. Sew Borders A, B and C together.

4. Sew A, B and C to the left side of the quilt.

COMPLETING THE TOP

1. Using the solid gray fabric, piece a border measuring 8½" x 72½". This is Border D. Sew to the right edge of quilt center.

2. Using the solid gray fabric, piece two borders each measuring 4½" x 64½" inches. This is Border E and F. Sew to the top and bottom of the quilt.

FINISHING AND BINDING

BACKING AND BATTING

Measure your quilt top and cut or piece your backing and batting to size allowing for at least 3 inches extra on all sides. (Check with your longarm quilter for other backing and batting size requirements.) For a modern look, you can piece your backing using leftover fabric from the top, along with other coordinating fabrics in your stash.

LAYERING AND BASTING

Layer the quilt top, batting and backing. Baste as desired.

QUILTING

Use your preferred method. For more information and references on quilting techniques, see "Quilting Your Modern Patriotic Quilt" on page 11.

BINDING

For a modern look, piece a binding using background fabric and the prints in the project. Or you can use a complementing striped or print fabric. For more information and resources on binding techniques, see "Bindings" on page 10.

Star template
Disappearing Four Patch with Stars

QUILT ASSEMBLY DIAGRAM: 64" X 80"

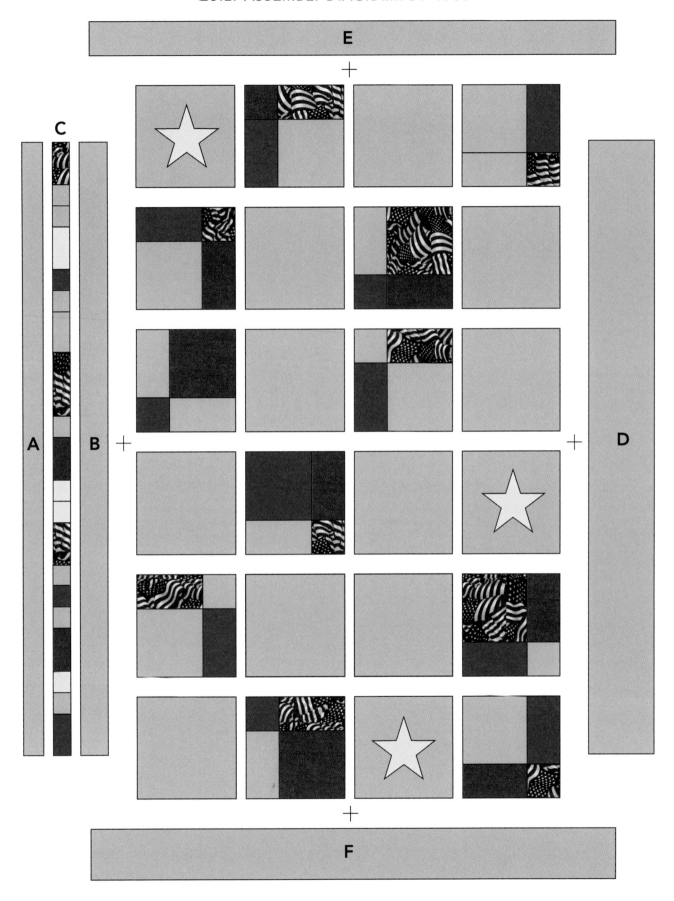

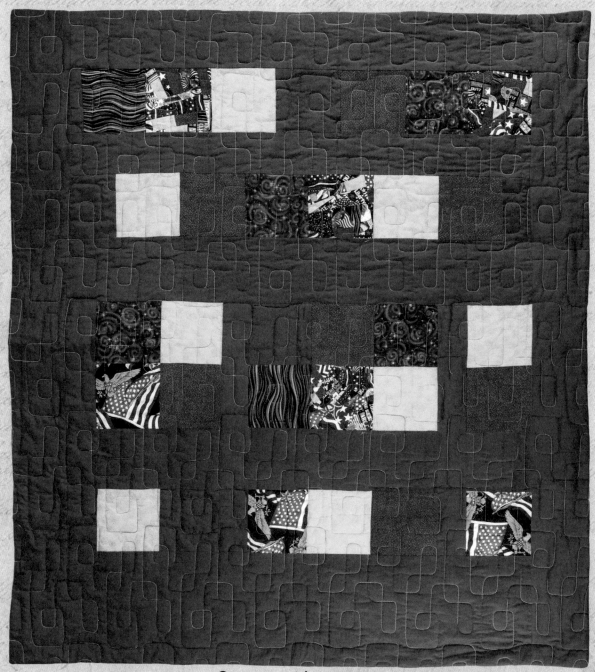

Squares with Improv

Bill of Rights Amendment 1

FREEDOM OF EXPRESSION AND RELIGION

Congress shall make no law respecting an establishment of religion,
or prohibiting the free exercise thereof; or abridging the freedom of
speech, or of the press; or the right of the people peaceably to assemble,
and to petition the Government for a redress of grievances.

FINISHED SIZE
45" x 49" crib size
with instructions to
enlarge quilt

DESIGNED BY
Carole Lyles Shaw

PIECED BY
Carole Lyles Shaw

QUILTED BY
Rose Ryan

MATERIALS LIST

Fabric yardage is
approximate; you
may use up scraps
or use a charm pack.

You will need:

• ½ yard (or more)
total of at least 5
assorted patriotic
print scraps

• ¼ yard of patriotic
print for focus fabric

• ⅜ yard of blue
patriotic print(s)

• ⅜ yard of red solid

• ⅜ yard of gold
solid

• 2½ yards of blue
solid for background

Squares with IMPROV

INTRODUCTION

This is a super easy quilt that you can easily piece in a weekend—
even if you make the larger lap quilt size. It's also great for using up
scraps from other patriotic quilt projects.

You will use these modern quilting design elements in this project:

Improvisational piecing
Asymmetry
Alternate grid layouts
Negative space
Infinite edges (faced binding)

CUTTING BASE BLOCKS

Cut 25 base blocks, each measuring 5½" square. I cut the following,
but you may mix them up however you like:

• 3 base blocks from the focus patriotic print
• 6 base blocks from the blue patriotic print(s)
• 8 base blocks from the gold solid
• 7 base blocks from the red solid
• 1 base block from the blue background fabric

CUTTING SPACER BLOCKS

I made the spacer blocks using the background fabric, but you may
use a coordinating solid instead to suit your tastes.

Block	Size to cut	Quantity
Block A	3½" x 5½"	2
Block B	2½" x 5½"	4
Block C	8½" x 5½"	2

CUTTING BACKGROUND FABRIC

Long rectangles can be pieced.

Block	Size to cut	Quantity
Block D	3½" x 35½"	1
Block E and F	5½" x 35½"	2
Border G and H	5½" x 38½"	2
Border I	3½" x 45½"	1
Border J	8½" x 45½"	1

ASSEMBLY THE IMPROV BLOCKS

The sample quilt includes 4 improvisationally pieced blocks measuring 5½" x 5½", but you may vary the number to suit your taste. Making an improvisationally-pieced block is very simple.

I start by making a pile of smallish scraps from other patriotic projects. My pieces measure about 2–4". If I have larger pieces, I cut them up first.

If you tend to get too precise about this, I suggest putting all of your scrap pieces of fabric in a plain paper bag. Then, without looking, draw out two different pieces of fabric at a time.

1. Sew two pieces of fabric together at a time on the longest common edge. Don't worry if they don't match. Keep selecting and sewing pairs together.

2. When you have a group of pairs, press them all.

3. Find pairs that have a common edge that matches (or nearly matches). You may have to do a bit of selective trimming. Start sewing pairs together.

4. Trim to get a straight edge. Sew more of these small blocks together.

5. Keep going until you have a block measuring about 6". Trim it down to 5½" x 5½".

TIPS

1. Avoid long straight lines that could end up exactly parallel to the sides of the block or a diagonal line that cuts the improvisational block into two halves. If you notice that your growing block has a long line, then cut the block in two across that line and add something else to both pieces.

2. Don't match and don't overthink it! This is a totally random process and it will look great if you stay loose and have fun.

COMPLETING THE TOP

Gather your base blocks, spacer blocks, background blocks and improv blocks. Assemble the quilt using the Crib Quilt Assembly Diagram.

1. Spacer Block A (3½"x 5½") is always paired in the same row with a Spacer Block B (2½" x 5½").

2. Spacer Block C (8½" x 5½") is always paired in the same row with a Spacer Block B (2½" x 5½").

3. Follow Assembly Diagram for remaining sections.

FINISHING AND BINDING

BACKING AND BATTING

Measure your quilt top and cut or piece your backing and batting to size allowing for at least 3 inches extra on all sides. (Check with your longarm quilter for other backing and batting size requirements.)

LAYERING AND BASTING

Layer the quilt top, batting and backing. Baste as desired.

QUILTING

Use your preferred method. For more information and references on quilting techniques, see "Quilting Your Modern Patriotic Quilt" on page 11.

BINDING

Bind the quilt using your preferred style. For more information and resources on binding techniques, see "Bindings" on page 10.

QUILT ASSEMBLY DIAGRAM: 45" X 49" CRIB SIZE

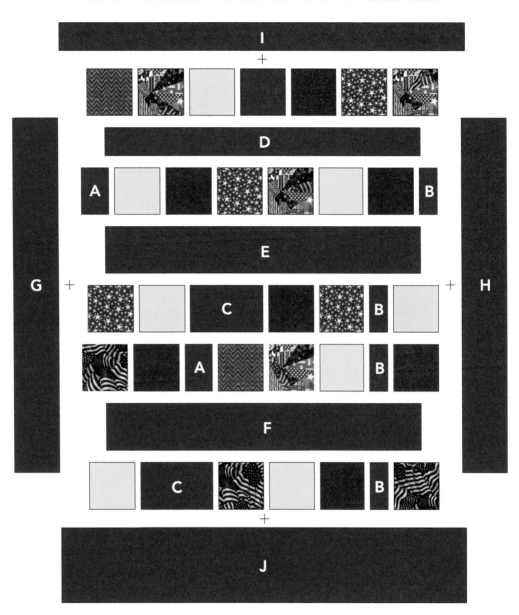

ENLARGING THE QUILT

This quilt is very easy to "upsize." See Quilt Assembly Diagram on page 59.

Decide how large you want the quilt to be. The inside width should be a multiple of 5 because the finished size of the base block is 5" x 5".

1. To make the quilt longer, add more rows. In the example shown, I decided on the inside length by simply adding an additional long horizontal blue block and 2 more rows of pieced blocks.

2. Make the quilt wider by adding more 5½" (unfinished size) squares to each row. You can also add more background blocks to the row. For example, you can add one Spacer Block C (8½" x 5½") and one Spacer Block B (2½" x 5½"). Notice that by adding these two sizes, you have added a space that measures 10½", twice the base 5½" square.

OUTSIDE BORDERS: After you make the central portion of the top, measure the four sides and cut and piece your outside borders accordingly.

Following this same process, you can easily increase the size of the quilt to any dimensions that you would like. Here are fabric estimates for a 50" x 64" quilt:

For the 50" x 64" quilt, you will need:

- 1 yard (or more) total of at least 5 assorted patriotic print scraps
- ½ yard of patriotic print for focus fabric
- ½ yard of blue patriotic print(s)
- ¾ yard of red solid
- ⅝ yard of gold solid
- 4 yards of blue solid for background

FINISHING AND BINDING

See "Finishing and Binding" on pages 56–57.

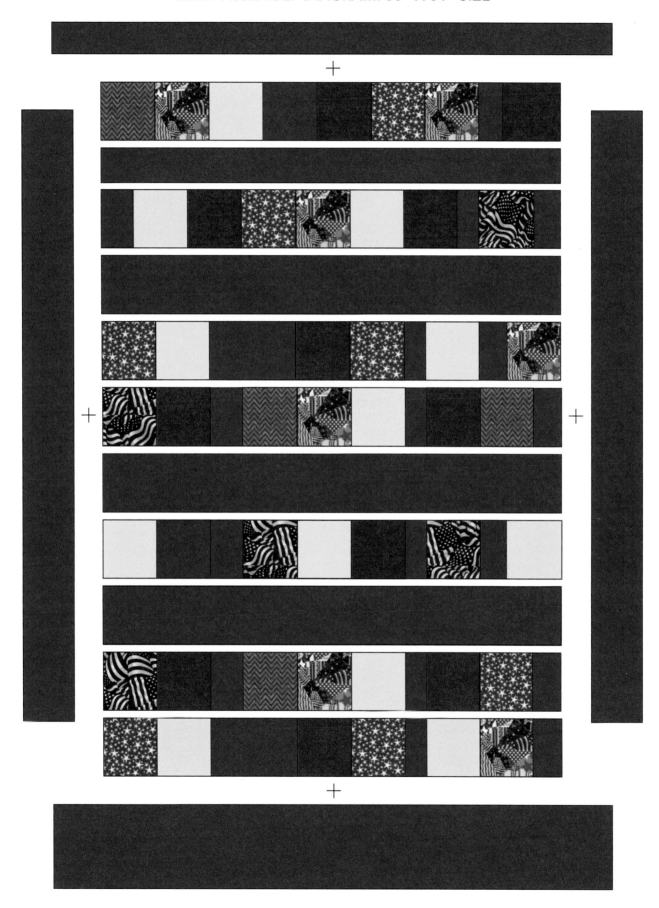

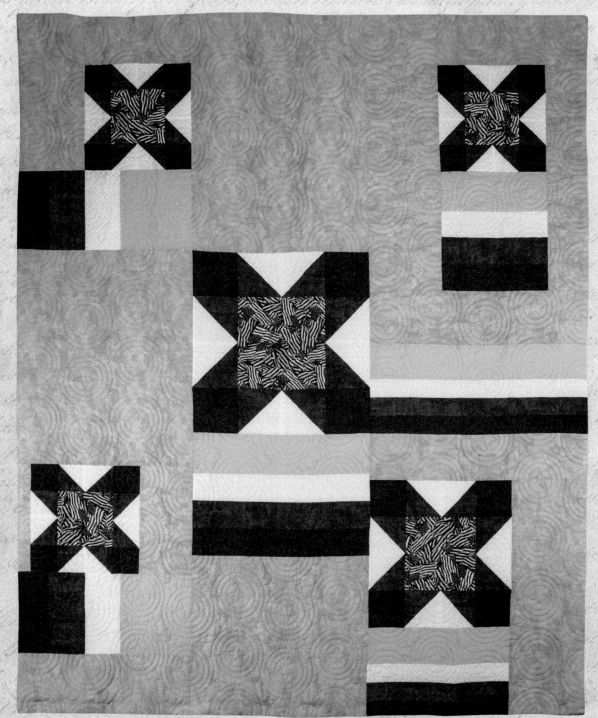

3D Stars & Strips

Bill of Rights Amendment 4

SEARCH AND SEIZURE

The right of the people to be secure in their persons, houses, papers, and effects, against unreasonable searches and seizures, shall not be violated, and no Warrants shall issue, but upon probable cause, supported by Oath or affirmation, and particularly describing the place to be searched, and the persons or things to be seized.

FINISHED SIZE
65" x 79"

DESIGNED BY
Carole Lyles Shaw

PIECED BY
Lynn Purple

QUILTED BY
Karlee Sandell

MATERIALS LIST

I used solids and tone-on-tone fabrics in the sample quilt. I chose fabrics that would provide high contrast so that the stars would really stand out.

You will need:

• ⅝ yard of red fabric

• ⅝ yard of dark blue fabric

• 1 yard of white fabric

• ¾ yard of yellow fabric

• 3 yards of light blue fabric for background

• 1 strip measuring 11" by 40" (width of fabric) of patriotic print

3D Stars & STRIPS

INTRODUCTION

This quilt is a playful, modern updating of two traditional blocks: the star and the rail fence. The star blocks are made in three sizes, so we are playing with scale. I used a dark blue fabric in the corner blocks of the stars which gives the quilt a 3D effect.

The strip blocks are a version of traditional rail fence blocks. These blocks use four colors (red, white, blue and yellow) and resemble the campaign ribbons that are given to service members. You will notice that the rail fence strips vary in width so we are still playing with scale.

This is a quilt with very easy piecing, so it's a great weekend project or a group quilt project.

You will use these modern quilting design elements in this project:

Modern traditionalism
Asymmetry and alternate grid layouts
Varied scale (star blocks in 3 sizes)
Use of negative space
Infinite edges (faced binding)

CUTTING BACKGROUND BLOCKS

Cut one of each block from the background fabric.

Block	Size to Cut	Block	Size to Cut
A	8½" x 18½"	K	18½" x 20½"
B	6½" x 12½"	L	6½" x 12 ½"
D	20½" x 24½"	N	8½" x 31½"
E	2½" x 12½"	O	5½" x 31½"
F	6½" x 12½"	P	6½" x 25½"
H	7½" x 20½"	R	6 ½" x 25½"
I	20½" x 27½"	T	9½" x 26½"

CUTTING STAR BLOCKS

Star Block	Base Squares for HSTs (red and white fabrics)	Corner Squares (dark blue fabric)	Center Squares (patriotic print)
Star #1: 12½" star blocks (3)	Cut 12 squares, 4½" x 4½", from red and white fabric to make 24 HSTs, 3½" x 3½"	Cut 12 squares, 3½" x 3½"	Cut 3 squares, 6½" x 6½"
Star #2: 20½" star block (1)	Cut 4 squares, 6½" x 6½", from red and white fabric to make 8 HSTs, 5½" x 5½"	Cut 4 squares, 5½" x 5½"	Cut 1 square, 10½" x 10½"
Star #3: 16½" star block (1)	Cut 4 squares, 5½" x 5½", from red and white fabric to make 8 HSTs, 4½" x 4½"	Cut 4 squares, 4½" x 4½"	Cut 1 square, 8½" x 8½"

See the tutorial section "Making Half-Square Triangles" on page 14. Here is a suggested cutting diagram for the star center squares using a strip of fabric measuring 11" by 40". I strongly recommend cutting the width a bit oversized (11") so that you know you have enough width for the 10½" square.

| 6½" square | 6½" square | 6½" square | 8½" square | 10½" square | leftover fabric |
| leftover fabric | | | leftover fabric | | |

leftover fabric

ASSEMBLY STAR BLOCKS

You will make the following:

- STAR #1: 12½" star blocks—make 3
- STAR #2: 20½" star block—make 1
- STAR #3: 16½" star block—make 1

All star blocks use the same assembly process.

The star points (red and white fabrics) are pieced half-square triangle blocks (HSTs). Instructions for making the HSTs can be found in the tutorial section "Making Half-Square Triangle Blocks" on page 14. Please read all instructions and make a test block before cutting your fabrics.

Assemble the star block in this order:

- TOP AND BOTTOM ROWS: Sew two HSTs together. Be sure to orient the HSTs correctly! Add one blue square on right and left.

half-square triangles

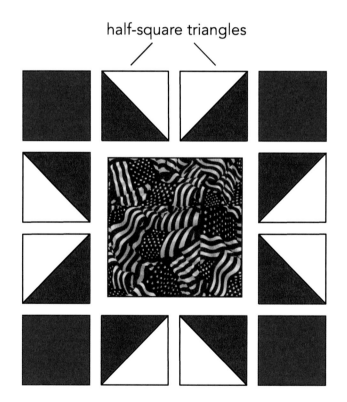

- MIDDLE ROW: Sew the HSTs together. Be sure to orient the HSTs correctly. Add to right and left side of center square.

- FINAL ASSEMBLY: Sew all three rows together.

CUTTING STRIP BLOCKS

Block letter	Size to cut	Quantity	From each of the following fabrics:
C	4½" x 9½"	1	red, white and dark blue
	8½" x 9½"	1	yellow
G	4½" x 9½"	1	red, white and dark blue
	8½" x 9½"	1	yellow
J	3½" x 20½"	1	red, white and dark blue
	5½" x 20½"	1	yellow
M	3½" x 12½"	1	red, white and dark blue
	4½" x 12½"	1	yellow
Q	2½" x 25½"	1	red, white and dark blue
	4½" x 25½"	1	yellow
S	2½" x 16½"	1	red, white and dark blue
	4½"x 16½"	1	yellow

ASSEMBLY STRIP BLOCKS

Each strip block is pieced in the exact same order: *sew red to blue along the long edge, then add white, then add yellow.* It's important to keep the order the same for each strip to achieve the layout shown.

Block	Assembled Block Size
C	9½"x 20½"
G	9½" x 20½"
J	14½" x 20½"
M	13½" x 12½"
Q	10½" x 25½"
S	10½" x 16½"

Notice that the strip widths and lengths are different for each strip block, so follow the cutting table carefully. I suggest pinning small labels with the block letter onto each finished strip block. That way, you will not get them mixed up when it is time to assemble the quilt top.

COMPLETING THE TOP

Using the Quilt Assembly Diagram, assemble the top.

I suggest sewing the blocks together into sections and columns for easy piecing as follows:

Left Column	Middle column	Right column
1. Sew B to Star #1	1. Sew I to Star #2	1. Sew L to third Star #1, then add M
2. Add A	2. Add J	2. Sew this section to N on left and O on right
3. Add Strip C	3. Add K	3. Sew P, Q and R together
4. Add D		4. Sew Star #3 to S
5. Sew second Star #1 to E		5. Sew this section to T
6. Add F		6. Sew all sections together as shown on the Assembly Diagram
7. Sew Strip G to H		
8. Sew these sections together as shown on Quilt Assembly Diagram		

FINISHING AND BINDING

BACKING AND BATTING

Measure your quilt top and cut or piece your backing and batting to size allowing for at least 3 inches extra on all sides. (Check with your longarm quilter for other backing and batting size requirements.) For a modern look, you can piece your backing using leftover fabric from the top, along with other coordinating fabrics in your stash.

LAYERING AND BASTING

Layer the quilt top, batting and backing. Baste as desired.

QUILTING

Use your preferred method. For more information and references on quilting techniques, see "Quilting Your Modern Patriotic Quilt" on page 11.

BINDING

Bind the quilt using your preferred style. For more information and resources on binding techniques, see "Bindings" on page 10.

QUILT ASSEMBLY DIAGRAM: 65" X 79"

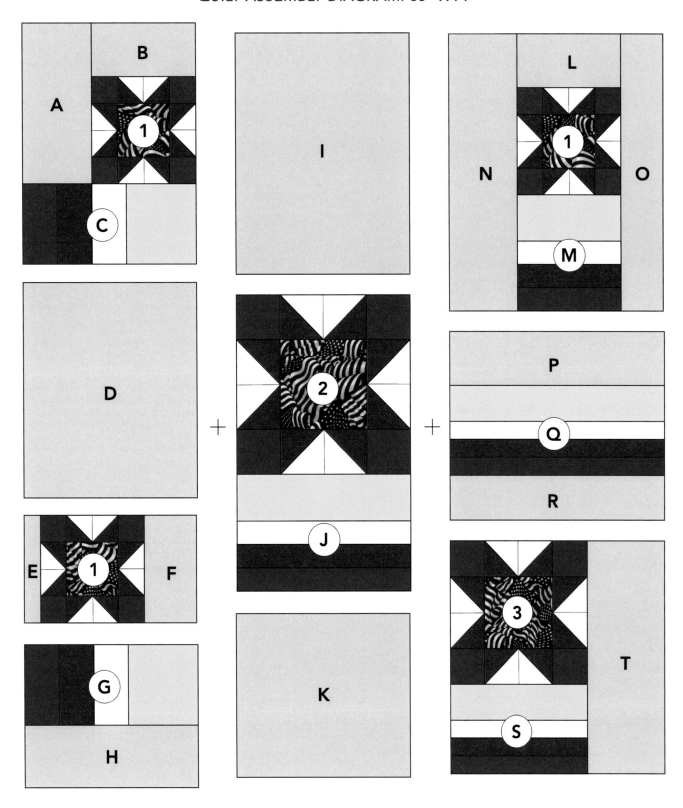

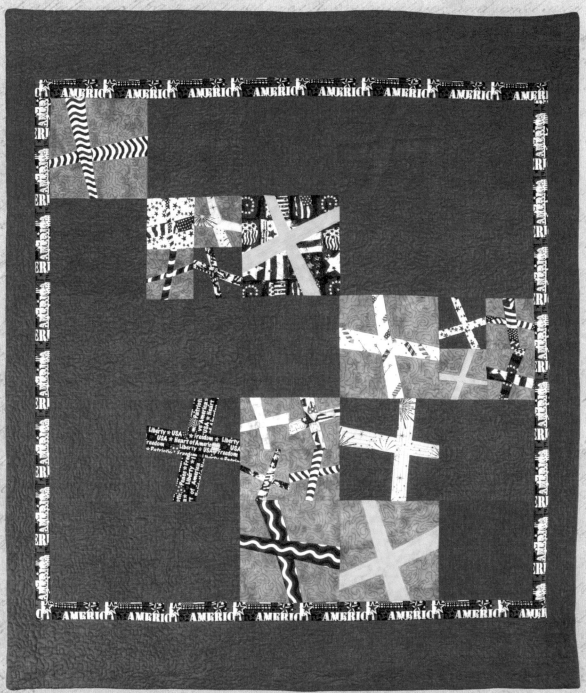

Patriotic X Blocks

Bill of Rights Amendment 13

SLAVERY AND INVOLUNTARY SERVITUDE

Neither slavery nor involuntary servitude, except as a punishment for
crime whereof the party shall have been duly convicted, shall exist within
the United States, or any place subject to their jurisdiction. Congress
shall have power to enforce this article by appropriate legislation.

FINISHED SIZE
48" x 55" crib quilt,
68" x 76" lap quilt
or 100" x 106"
king-size quilt

Instructions to make
a lap quilt and a
king-size quilt can
be found starting on
page 72.

DESIGNED BY
Carole Lyles Shaw

PIECED BY
Jayne Namerow

QUILTED BY
Debra Jalbert

**MATERIALS LIST
FOR CRIB SIZE**
You will need:

• 3 yards of dark
blue tone-on-tone
for background

• ¼ yard of light
blue tone-on-
tone for X blocks
background (or
other fabrics of your
choice)

• ⅛ yard yellow solid

• ⅝ yard patriotic
print for inner
borders

• ⅛ yard each
(approximately
1½ yards) of 4–6
patriotic prints

Patriotic
X BLOCKS

INTRODUCTION

I recommend choosing a mottled or tone-on-tone fabric for the dark
blue and light blue background fabrics, but solids work as well.

You will use these modern quilting design elements in this project:

> *Asymmetry and alternate grid layouts*
> *Use of negative space*
> *Playing with scale*
> *Improvisation:* experimenting and playing with block design,
> quilt layout, fabric choices

CRIB QUILT

CUTTING BACKGROUND BLOCKS
AND OUTER BORDERS (DARK BLUE)

Long strips may be pieced.

Sizes to cut and/or piece	Quantity	Layout placement
8½" x 8½"	15	Background blocks
3½" x 43½"	2	Outer borders A and B
6½" x 48½"	2	Outer borders C and D

CUTTING INSIDE BORDERS (PATRIOTIC PRINT)

Long strips may be pieced.

Sizes to cut and/or piece	Quantity	Layout placement
1½" x 40½"	2	Left and right inner borders
2½" x 42½"	2	Top and bottom inner borders

CUTTING X BLOCKS

Each X block will be unique and fabric pairing is up to you. Play, have some fun and use up scraps of patriotic fabrics from other projects.

When you select the fabric for each X square, go for high contrast so that the X really stands out in contrast to the background. In the sample quilt, I used a yellow fabric in some of the X's for pop!

Some of the X blocks have a light blue fabric for the background, but you can also use a patriotic print fabric as a background. I included a variation where the dark blue background fabric is used in the X block so that the X just floats. This is an improvisational process and I look forward to how you will interpret this pattern. Here are suggested fabric choices in the table—but remember that you can use the YELLOW fabric for X strips or even as a background. You can also use a patriotic print as a background. Improvise and have fun playing with combinations!

Block name	Quantity	Block size	Fabric to cut	Size to cut	Quantity	Purpose
Small X blocks to make the 3 Four-X Blocks	12	4½" x 4½"	Light blue	6" x 6"	12	1 square per small X block background
			Various patriotic prints and yellow fabric	1" to 1½" x 9"	24 (12 pairs of 2)	X strips
Large X Blocks	7	8½" x 8½"	Light blue	10" x 10"	7	1 square per large X block background
			Various patriotic prints and yellow fabric	1½" to 2½" x 12"	14 (7 pairs of 2)	X strips

ASSEMBLY X BLOCKS

There are two different types of X blocks:

- The four-X block is made up of four small X blocks, each measuring 4½" unfinished. (This is a variation on a four-patch block!) After assembly, the four-X block measures 8½" unfinished.

- The large X block measures 8½" unfinished.

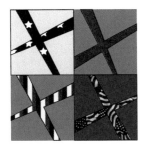
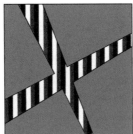
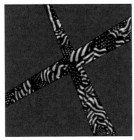
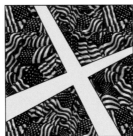

Follow these instructions for making the X blocks. I suggest making one X block at a time.

1. Cut your background square. See cutting table at left for size of background square.

2. Cut the square diagonally—no measuring needed. Just be sure to leave at least 1" to 1½" from each corner.

3. Choose two contrasting fabric strips. Cut your cross strips freehand—

in other words, they can vary in width from one end to the other for an even more improvisational look! Strips should be slightly longer than the block and overlap each side by about an inch or so.

4. Sew one strip into this cut, reattaching the background pieces on either side of the strip. Press seams open. Do not trim the ends; they should slightly extend beyond the sides of the square.

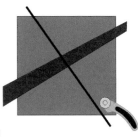

5. Cut this square diagonally a second time, making sure to cut on the two sides that do not have strips sewn in. Be sure to leave at least 1 inch from the edges. You are creating a wide X.

6. Sew in the second strip, matching the intersection as best you can. It may not line up perfectly and that's okay. TIP: *line up the block, then flip it carefully and pin this intersection.*

7. Press seams open and trim to needed size according to cutting table.

COMPLETING THE TOP

For the crib quilt, you will need a total of 25 blocks:

- 3 four-X blocks
- 7 large X blocks
- 15 background blocks

Arrange the quilt as shown in my example or change it up to suit your tastes. You can also change up the number of X blocks you make—improvise and have some fun!

ENLARGING THE QUILT

Go to page 72–75 for instructions on enlarging this quilt to lap quilt and king-size quilt sizes.

FINISHING AND BINDING
ALL SIZES

BACKING AND BATTING

Measure your quilt top and cut or piece your backing and batting to size allowing for at least 3 inches extra on all sides. (Check with your longarm quilter for other backing and batting size requirements.) For a modern look, you can piece your backing using leftover fabric from the top, along with other coordinating fabrics in your stash.

LAYERING AND BASTING

Layer the quilt top, batting and backing. Baste as desired.

QUILTING

Use your preferred method. For more information and references on quilting techniques, see "Quilting Your Modern Patriotic Quilt" on page 11.

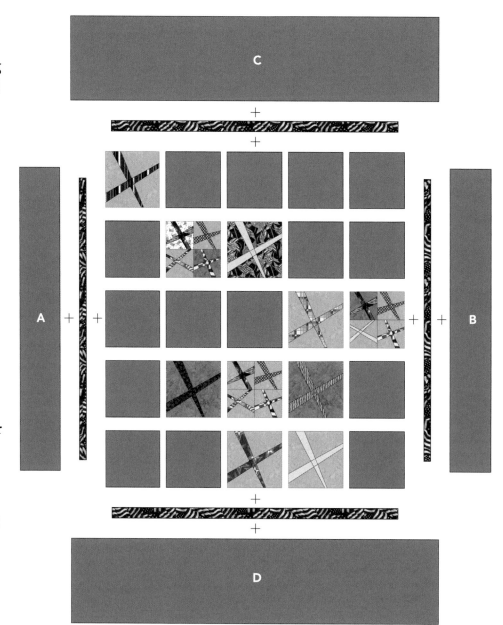

BINDING

Bind the quilt using your preferred style. For more information and resources on binding techniques, see "Bindings" on page 10.

Those who deny *freedom* to others deserve it not for themselves.

ABRAHAM LINCOLN

PATRIOTIC X BLOCKS: LAP QUILT

Block sizes remain the same and the instructions for making the X blocks (found on page 69) also remain the same. See the Quilt Assembly Diagram on page 73 for suggested layout and number of small and large X blocks needed. You can change this layout to suit your inspiration.

CUTTING X BLOCKS

For the lap quilt, mix Four-X blocks with large X blocks in any combination you choose. I recommend making 12–14 X blocks, which preserves the negative space. Adjust number of background blocks accordingly.

Block name	Block size	FOR EACH BLOCK:		
		Fabric to cut:	Size to cut:	Quantity
Small X blocks *to make the Four-X Blocks*	4½" x 4½"	light blue or print	6" x 6"	1 square per small X block
		yellow or print	1" to 1½" x 9"	2 strips of same fabric per small X block
Large X Blocks	8½" x 8½"	light blue or print	10" x 10"	1 square per large X block
		yellow or print	1½" to 2½" x 12"	2 strips of same fabric per large X block

CUTTING BACKGROUND BLOCKS AND OUTER BORDERS (DARK BLUE)

Long strips may be pieced.

Sizes to cut and/or piece	Number of pieces	Layout placement
8½" x 8½"	26-30	Background blocks
8½" x 60½"	2	Outer borders A and B
6½" x 68½"	2	Outer borders C and D

CUTTING INSIDE BORDERS (PATRIOTIC PRINT)

Long strips may be pieced.

Sizes to cut and/or piece	Number of pieces	Layout placement
2½" x 56½"	2	Left and right inner borders
2½" x 52½"	2	Top and bottom inner borders

QUILT ASSEMBLY DIAGRAM: 68" X 76" LAP SIZE

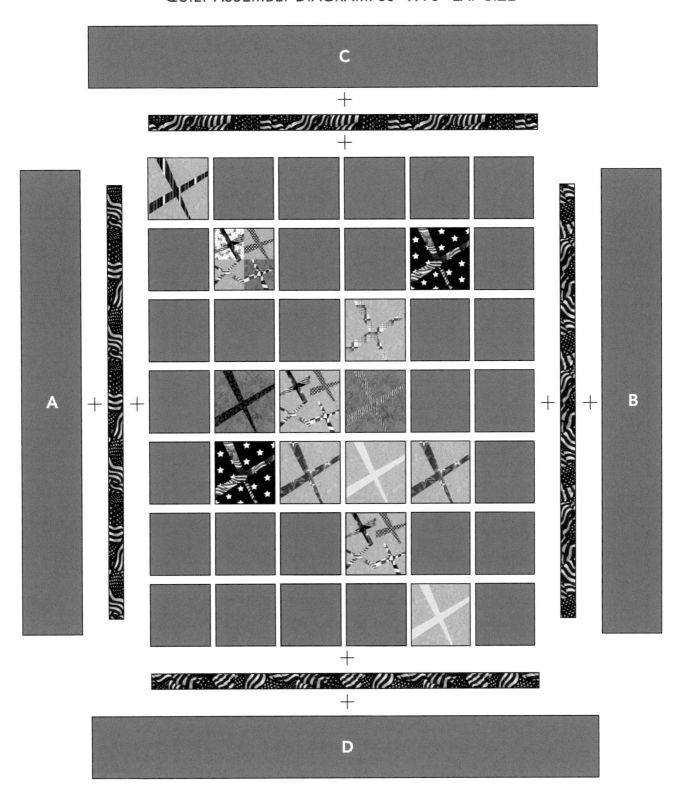

PATRIOTIC X BLOCKS: KING-SIZE QUILT

Block sizes remain the same and the instructions for making the X blocks (found on page 69) also remain the same. See the Quilt Assembly Diagram on page 75 for suggested layout and number of small and large X blocks needed. You can change this layout to suit your inspiration.

(found on page 69)
See the Quilt Assembly Diagram on page 75

MATERIALS LIST FOR KING-SIZE

You will need:

• 8¼ yards of dark blue tone-on-tone for background

• 1 yard of light blue tone-on-tone for X blocks background (or other fabrics of your choice)

• ⅜ yard yellow solid

• 1 yard patriotic print for inner borders

• ¼ yard each (approximately 2½ yards) of 10–14 patriotic prints

CUTTING X BLOCKS

For the king-size quilt, mix four-X blocks with large X blocks in any combination you choose. I recommend making 20–24 X blocks and adjust number of background blocks accordingly.

Block name	Block size	FOR EACH BLOCK: Fabric to cut:	Size to cut:	Quantity
Small X blocks *to make the Four-X Blocks*	4½" x 4½"	light blue or print	6" x 6"	1 square per small X block
		yellow or print	1" to 1½" x 9"	2 strips of same fabric per small X block
Large X Blocks	8½" x 8½"	light blue or print	10" x 10"	1 square per large X block
		yellow or print	1½" to 2½" x 12"	2 strips of same fabric per large X block

CUTTING BACKGROUND BLOCKS AND OUTER BORDERS (DARK BLUE)

Long strips may be pieced.

Sizes to cut and/or piece	Number of pieces	Layout placement
8½" x 8½"	76–80	Background blocks
8½" x 104½"	2	Outer borders A and B
11½" x 106½"	2	Outer borders C and D

CUTTING INSIDE BORDERS (PATRIOTIC PRINT)

Long strips may be pieced.

Sizes to cut and/or piece	Number of pieces	Layout placement
2½" x 80½"	2	Left and right inner borders
2½" x 104½"	2	Top and bottom inner borders

QUILT ASSEMBLY DIAGRAM: 100" X 106" KING QUILT

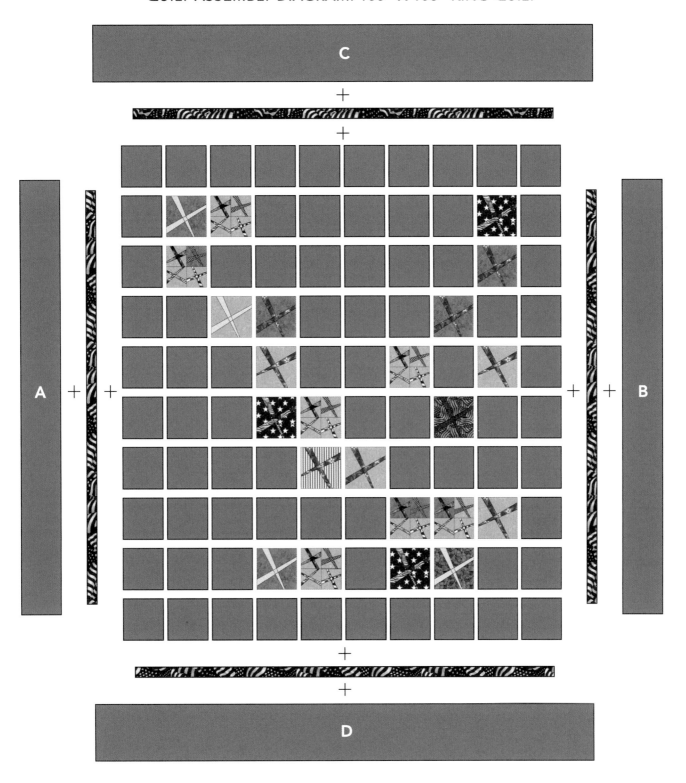

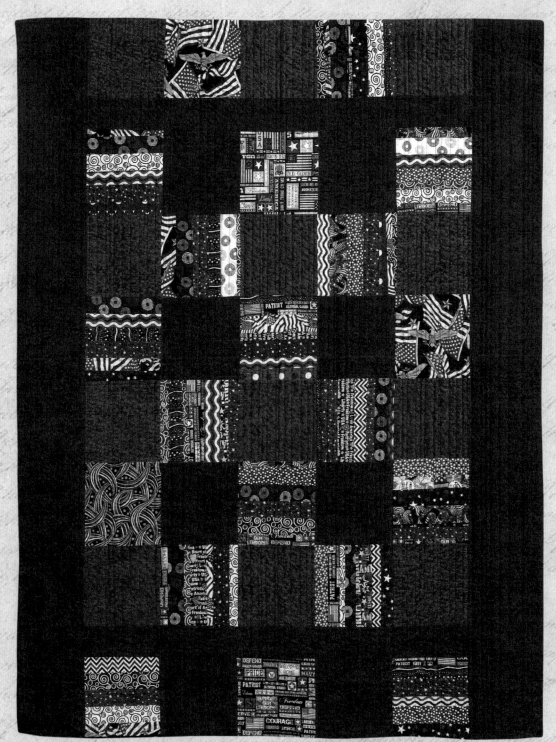

Patriotic Rail Fence

Bill of Rights Amendment 15

RIGHTS OF CITIZENS TO VOTE

The right of citizens of the United States to vote shall not be denied or abridged by the United States or by any State on account of race, color, or previous condition of servitude. The Congress shall have power to enforce this article by appropriate legislation.

FINISHED SIZE
63" x 78"

DESIGNED BY
Carole Lyles Shaw

PIECED BY
Carole Lyles Shaw

QUILTED BY
Rose Ryan

MATERIALS LIST

Use your scraps stash!

You will need:

• 2½ yards of Solid #1 (dark blue in the sample)

• 1 yard of Solid #2 (red in sample)

• A minimum of 8 assorted patriotic prints, totaling approximately 2½ yards. This can be a mix of fat eighths and fat quarters, but choose two focus prints at least a fat quarter in size. Alternatively, you may choose ½ yard of one print to be the focus print.

Patriotic RAIL FENCE

INTRODUCTION

This quilt alternates rail fence blocks with focus print blocks. You will use these modern quilting design elements in this project:

Modern traditionalism
Negative space
Asymmetry (no top or bottom border)
Infinite edges (faced bindings)

ASSEMBLY RAIL FENCE BLOCKS

When rail fence blocks are traditionally pieced, each strip measures exactly the same width. Instead, you will modernize the block by randomly cutting your strips in different widths.

Make 15 rail fence blocks, each measuring 9½" x 9½" unfinished.

TIPS FOR MAKING RAIL FENCE BLOCKS

1. You will need approximately 7 to 8 strips for each rail fence block. I suggest cutting strips from each print ranging in size from 1" to 2½" width x 10" length.

2. Lightly starch the fabric before cutting the strips to help keep them straight.

3. When possible, cut along the straight of grain. If your fabric is a scrap that is cross grain, make sure to starch it a bit more heavily.

4. Mix up the order of the fabrics in each rail fence. I usually make one block at a time so that I don't accidentally make them all look the same. (In other words, do not make long straight sets like you might do when making traditional symmetrical rail fence blocks.)

Rail fence blocks close up

CUTTING SOLIDS AND FOCUS PRINTS BLOCKS

In the sample quilt, I used several different focus patriotic prints from my stash. Cut the following blocks:

Fabric	Size to cut	Quantity
Solid #2 (red)	9½" x 9½"	12
Solid #1 (dark blue)	9½" x 9½"	8
Patriotic print(s)	9½" x 9½"	5

CUTTING BORDERS

From Solid #1 (dark blue), cut the following strips. Long sections can be pieced.

Size to cut	Quantity	Piece name
3½" x 45½"	2	A1, A2
9½" x 78½"	2	B1, B2

COMPLETING THE TOP

Assemble the quilt using the layout shown. Notice that I changed the orientation of the rail fence blocks in each row. I also deliberately made the top and bottom rows different to introduce a bit of asymmetry. You can make other choices in your layout to make this quilt uniquely your own.

FINISHING AND BINDING

BACKING AND BATTING

Measure your quilt top and cut or piece your backing and batting to size allowing for at least 3 inches extra on all sides. (Check with your longarm quilter for other backing and batting size requirements.) For a modern look, you can piece your backing using leftover fabric from the top, along with other coordinating fabrics in your stash.

LAYERING AND BASTING

Layer the quilt top, batting and backing. Baste as desired.

QUILTING

Use your preferred method. For more information and references on quilting techniques, see "Quilting Your Modern Patriotic Quilt" on page 11.

BINDING

Using leftover fabrics, bind the quilt using your preferred style. For more information and resources on binding techniques, see "Bindings" on page 10.

QUILT ASSEMBLY DIAGRAM: 63" X 78"

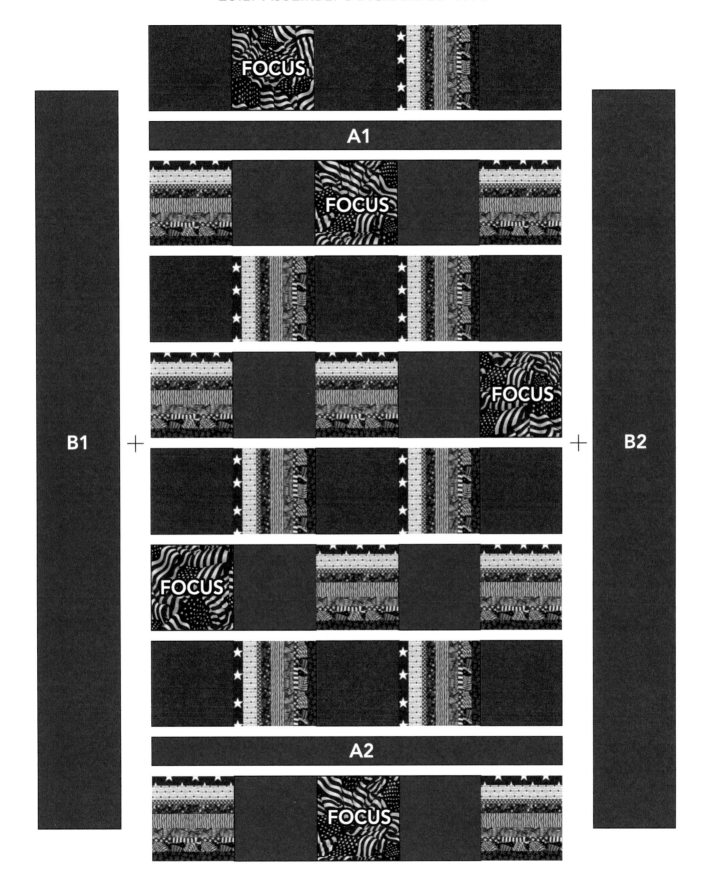

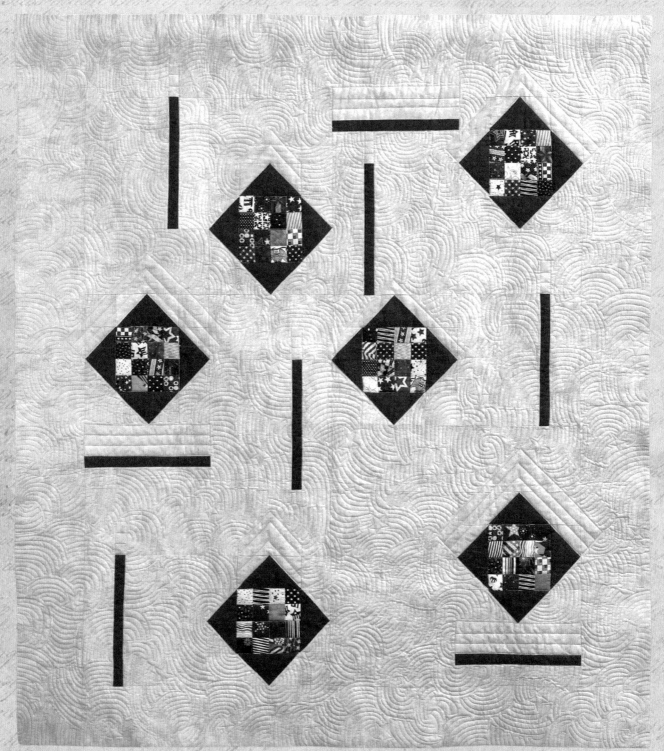

Patriotic Diamonds

Bill of Rights Amendment 19

WOMEN'S SUFFRAGE RIGHTS

The right of citizens of the United States to vote shall not be denied or abridged by the United States or by any State on account of sex. Congress shall have power to enforce this article by appropriate legislation.

FINISHED SIZE
62" x 68"

DESIGNED BY
Carole Lyles Shaw

PIECED BY
Ethel Morrison

QUILTED BY
Debra Jalbert

MATERIALS LIST

You will need:

• 4 yards of Solid #1 (gray in the sample)

• 1 yard of Solid #2 (red in the sample)

• Assorted patriotic prints in 2" squares. Scraps are ideal for this project! You will need sixteen 2" squares for each diamond block (a total of 96 squares for the quilt layout shown).

Patriotic DIAMONDS

INTRODUCTION

While this quilt looks complicated in construction, it's actually broken down into a structure that is quite easy to piece.

You will use these modern quilting design elements in this project:

Modern traditionalism
Asymmetry and alternate grid layouts
Negative space

CUTTING DIAMOND-AND-SQUARES BLOCKS

Fabric	Patches	Size to cut	Quantity
Assorted prints	16-Patch Square	2" x 2"	96
Solid #1 (gray)	Squares for HSTs	5" x 5"	24
Solid #1 (gray)	Corner squares	3½" x 3½	24
Solid #2 (red)	Squares for HSTs	5" x 5"	24

ASSEMBLY DIAMOND-AND-SQUARES BLOCKS

Make 6 Diamond-and-Squares blocks, each 12½" x 12½" unfinished. Instructions to make one block:

1. Piece a 16-patch square for the center using the 2" print squares: Arrange the patches randomly so that each 16-patch square looks different. When assembling the square, be careful to mix how you place the prints so that you do not have the same print next to itself. Keep it looking random.

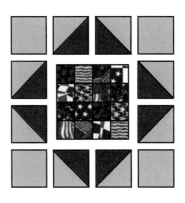

Sew 2" assorted print squares into 4 rows with 4 patches in each row. The unfinished size of the 16-patch square should be 6½" x 6½".

2. Create half-square triangles: Using the gray and red 5" x 5" squares, make 8 half-square triangles, measuring 3½" x 3½" unfinished. See tutorial section "Making Half-Square Triangles" on page 14 for instructions.

3. Assemble the block: Using the 16-patch squares, the half-square triangles and the corner squares, assemble the block. See assembly diagram on page 81.

CUTTING BLOCKS A, B, C, D, E
(SEE QUILT ASSEMBLY DIAGRAM)

Block	Fabric	Size to cut	Quantity
A	Gray solid	8½" x 12½"	5
A	Gray solid	3½" x 12½"	5
A	Red solid	1½" x 12½"	5
B	Gray solid	6½" x 12½"	4
C	Gray solid	3½" x 12½"	3
C	Gray solid	2½" x 12½"	3
C	Red solid	1½" x 12½"	3
D	Gray solid	12½" x 18½"	1
E	Gray solid	6½" x 24½"	2

ASSEMBLY BLOCKS A & C

BLOCK A

Gather 3 strips (2 gray and 1 red) and piece as shown. Make 5 of Block A, each measuring 12½" x 12½" unfinished.

BLOCK C

Gather 3 strips (2 gray and 1 red). Piece these 3 strips as shown. Make 3 of Block C, each measuring 6½" x 12½" unfinished.

CUTTING BORDERS

Long sections can be pieced.

Border	Fabric	Size to cut	Quantity
F	Gray solid	7½" x 54½"	2
G	Gray solid	6½" x 62½"	1
H	Gray solid	8½" x 62½"	1

COMPLETING THE TOP

Using the pieced and cut blocks and borders, assemble the quilt using the Quilt Assembly Diagram on page 83.

FINISHING AND BINDING

BACKING AND BATTING

Measure your quilt top and cut or piece your backing and batting to size allowing for at least 3 inches extra on all sides. (Check with your longarm quilter for other backing and batting size requirements.) For a modern look, you can piece your backing using leftover fabric from the top, along with other coordinating fabrics in your stash.

LAYERING AND BASTING

Layer the quilt top, batting and backing. Baste as desired.

QUILTING

Use your preferred method. For more information and references on quilting techniques, see "Quilting Your Modern Patriotic Quilt" on page 11.

BINDING

Bind the quilt using your preferred style. For more information and resources on binding techniques, see "Bindings" on page 10.

QUILT ASSEMBLY DIAGRAM: 62" X 68"

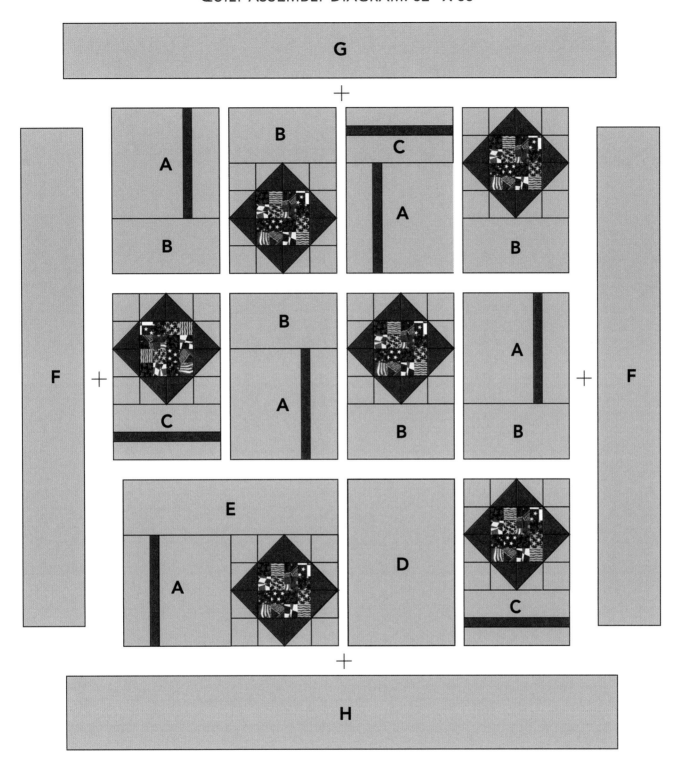

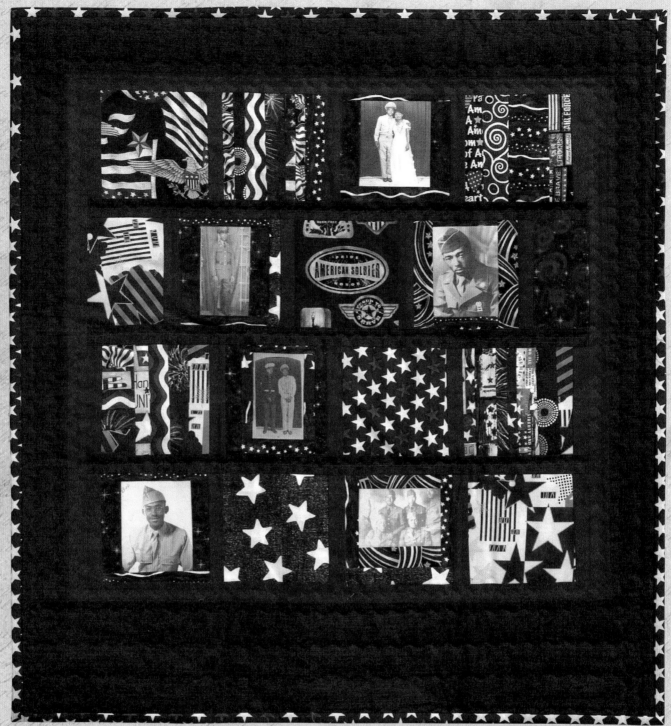

Salute to Heroes

In Congress, July 4, 1776

THE UNANIMOUS DECLARATION OF THE THIRTEEN UNITED STATES OF AMERICA

We hold these truths to be self-evident, that all men are created equal,
that they are endowed by their Creator with certain unalienable Rights,
that among these are Life, Liberty and the pursuit of Happiness.

FINISHED SIZE
36" x 36"

DESIGNED BY
Carole Lyles Shaw

**PIECED AND
QUILTED BY**
Carole Lyles Shaw

MATERIALS LIST
You will need:

• 1 yard of solid #1 (dark blue in the sample)

• ½ yard solid #2 (red in sample)

• A minimum of 8 fat quarters of assorted patriotic prints

• 6 photos printed on 100% cotton fabric. I recommend white June Tailor Sew-In Colorfast™ Fabric Sheets for inkjet printers, available in local quilt shops and online.

Salute to
HEROES

INTRODUCTION

I am ending this book by coming full circle with a project that reflects where I began my journey into patriotic quilts. In this sample, I've used some of the family photos that I mentioned in the Introduction chapter and I hope it inspires you to do the same.

This wall hanging is a great way for you to use photos printed on fabric to honor the service of a family member. You can use contemporary photos or dig into your family files and use old photos like I did in the sample quilt.

You will use these modern quilting design elements in this project:

Asymmetry
Alternate grid layout
Modern traditionalism: reinterpreting the past by making traditional rail fence blocks in a new way

CUTTING BLOCKS

Fabric	Block	Size to cut	Quantity
Solid #2 (red in sample)	A	1½" x 5½"	19
Patriotic prints	B	5½" x 5½"	7
Patriotic prints	C, E	1" to 1¾" x 6"	16–20

See Assembly instructions for Rail Fence Blocks on page 86.

CUTTING BORDERS

Fabric	Block	Size to cut	Quantity
Solid #1 (blue in sample)	F	1½" x 25½"	2
Solid #1 (blue in sample)	I	4½" x 25½"	2
Solid #1 (blue in sample)	J	4½" x 36½"	2
Solid #2 (red in sample)	G	1½" x 23½"	2
Solid #2 (red in sample)	H	1½" x 27½"	2

ASSEMBLY
RAIL FENCE BLOCKS (BLOCK C AND E)

Traditional rail fence blocks are pieced with each rail measuring exactly the same width. However, for a more improvisational look, you will cut your rail fence strips different widths.

After cutting your strips, sew long sides together to piece them into blocks that measure 5½" x 5½" (C) and 3½" x 5½" (E) and unfinished. Make 4 blocks.

TIPS FOR MAKING THESE BLOCKS
(read all instructions before starting):

1. To make cutting easier and to ensure accuracy, I usually cut my strips a bit longer and then trim each block to size.

2. Starch the fabric before cutting the strips. This will help you keep them straight when you sew them together.

3. When possible, cut along the straight of grain. But if your fabric is a scrap that is cross grain, make sure to starch it a bit more heavily to keep the rails parallel.

4. Mix up the order of the fabrics in each rail fence block. I usually make one block at a time so that I don't make them all look the same. (In other words, do not make long straight sets.)

ASSEMBLY PHOTO BLOCK D

In this sample layout, I used six sepia-toned family photos. I printed them in sepia colors to keep the antique feel. Read all instructions below before printing your photos.

1. The fabric sheets that I used did not require any preparation. They come out of the package ready to print.

2. In photo editing software, arrange 2 to 4 photos per sheet. Each photo should measure about 3" x 4" so several should fit easily on one 8½" x 11" sheet. Be sure to leave at least 1" of white space around each photo.

3. After printing, follow manufacturer instructions to remove the backing paper and iron the fabric to "set" the ink.

4. Cut out each photo, leaving ¼" of white space on all four sides. This is your seam allowance.

5. Measure the photo and decide how large the border needs to be so that the completed block measures 5½" x 5½" unfinished. Remember to add ½" seam allowances to your border width calculations. Cut border strips from one of your patriotic prints and sew on to the photo. Trim, if needed, to 5½" x 5½".

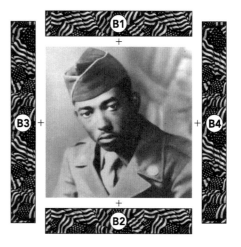

Printed area of photo above measures 3" x 4". With seam allowance, this photo measures 3½" x 4½". Borders B1 and B2: Cut 2 strips, 1½" x 3½" from a patriotic print. Sew to top and bottom. Borders B3 and B4: Cut 2 strips from the same or a different patriotic print, each measuring 1" x 5½". Sew to right and left sides. Photo block should now measure 5½" x 5½".

Use a similar process to sew borders to any photos that are less than 5½" square.

This layout is a variation of the layout shown in the sample quilt on page 84. Your layout will vary depending on the number of photos and overall size of the quilt.

COMPLETING THE TOP

Follow the quilt assembly diagram to complete the top.

Make this quilt your own design!

You can easily change the layout of this mini quilt to suit your needs. For example, you might use five photos and put more rail fence blocks into the layout. Or you might use ten photos and eliminate some of the rail fence or solid blocks. It's up to you!

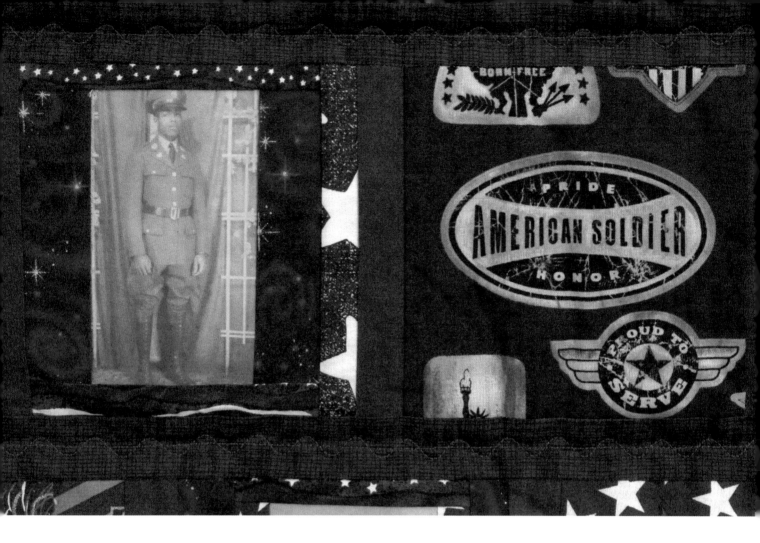

FINISHING AND BINDING

BACKING AND BATTING

Measure your quilt top and cut or piece your backing and batting to size allowing for at least 3 inches extra on all sides. (Check with your longarm quilter for other backing and batting size requirements.) For a modern look, you can piece your backing using leftover fabric from the top, along with other coordinating fabrics in your stash.

LAYERING AND BASTING

Layer the quilt top, batting and backing. Baste as desired.

QUILTING

Use your preferred method. You can use straight-line quilting for a modern look or use free motion quilting for a more organic look. I quilted this sample using the meander stitch (S curve) on my domestic machine. For more information and references on quilting techniques, see "Quilting Your Modern Patriotic Quilt" on page 11.

BINDING

Bind the quilt using your preferred style. For more information and resources on binding techniques, see "Bindings" on page 10.

PLANNING NOTES FOR SALUTE TO HEROES QUILT

Make notes on this page about how many photos you will use and how many pieced and whole blocks you will need to make.

QUILT PLANNING

Project Name: _____

Pattern: _____ Quilt size: _____

Recipient: _____

Planning Notes (changes to pattern, other notes)

FABRIC *(swatches can be taped on page 2)*

Fabric:		Fabric:	
Amount on hand:	Amount to buy:	Amount on hand:	Amount to buy:
Fabric:		Fabric:	
Amount on hand:	Amount to buy:	Amount on hand:	Amount to buy:
Fabric:		Fabric:	
Amount on hand:	Amount to buy:	Amount on hand:	Amount to buy:
Fabric:		Backing Fabric:	
Amount on hand:	Amount to buy:	Amount on hand:	Amount to buy:
Fabric:		Batting:	
Amount on hand:	Amount to buy:	Amount on hand:	Amount to buy:

SHOPPING LIST *(Thread, Rulers, Basting Spray, Needles, Fabric Glue)*

- ☐
- ☐
- ☐
- ☐
- ☐
- ☐

- ☐
- ☐
- ☐
- ☐
- ☐
- ☐

QUILT PLANNING

Project Name: _____

<table>
<tr><td colspan="2" align="center">SWATCHES</td><td>PROGRESS CHART</td></tr>
<tr>
<td>Amount on hand:

Amount to buy:</td>
<td>Amount on hand:

Amount to buy:</td>
<td>

☐ Fabrics pulled from stash

☐ Fabrics purchased

☐ Batting from stash or purchased

☐ Print paper piecing templates

☐ Test blocks made

☐ Pieced top

☐ Pieced backing

☐ Quilting designed & completed

☐ Make binding

☐ Make and attach label

☐ Photograph

☐ Send to recipient or keep
</td>
</tr>
<tr>
<td>Amount on hand:

Amount to buy:</td>
<td>Amount on hand:

Amount to buy:</td>
<td>Amount on hand:

Amount to buy:</td>
</tr>
<tr>
<td>Amount on hand:

Amount to buy:</td>
<td>Amount on hand:

Amount to buy:</td>
<td>Amount on hand:

Amount to buy:</td>
</tr>
</table>

QUILT PLANNING

Project Name: _____

Pattern: _____ Quilt size: _____

Recipient: _____

Planning Notes (changes to pattern, other notes)

FABRIC *(swatches can be taped on page 2)*

Fabric:	Fabric:
Amount on hand: Amount to buy:	Amount on hand: Amount to buy:
Fabric:	Fabric:
Amount on hand: Amount to buy:	Amount on hand: Amount to buy:
Fabric:	Fabric:
Amount on hand: Amount to buy:	Amount on hand: Amount to buy:
Fabric:	Backing Fabric:
Amount on hand: Amount to buy:	Amount on hand: Amount to buy:
Fabric:	Batting:
Amount on hand: Amount to buy:	Amount on hand: Amount to buy:

SHOPPING LIST *(Thread, Rulers, Basting Spray, Needles, Fabric Glue)*

☐ ☐
☐ ☐
☐ ☐
☐ ☐
☐ ☐
☐ ☐

QUILT PLANNING

Project Name: _____

SWATCHES		PROGRESS CHART
Amount on hand: Amount to buy:	Amount on hand: Amount to buy:	☐ Fabrics pulled from stash ☐ Fabrics purchased ☐ Batting from stash or purchased ☐ Print paper piecing templates ☐ Test blocks made ☐ Pieced top ☐ Pieced backing ☐ Quilting designed & completed ☐ Make binding ☐ Make and attach label ☐ Photograph ☐ Send to recipient or keep
Amount on hand: Amount to buy:	Amount on hand: Amount to buy:	Amount on hand: Amount to buy:
Amount on hand: Amount to buy:	Amount on hand: Amount to buy:	Amount on hand: Amount to buy:

QUILT PLANNING

Project Name: _____

Pattern: _____ Quilt size: _____

Recipient: _____

Planning Notes (changes to pattern, other notes)

FABRIC *(swatches can be taped on page 2)*

Fabric:	Fabric:
Amount on hand: Amount to buy:	Amount on hand: Amount to buy:
Fabric:	Fabric:
Amount on hand: Amount to buy:	Amount on hand: Amount to buy:
Fabric:	Fabric:
Amount on hand: Amount to buy:	Amount on hand: Amount to buy:
Fabric:	Backing Fabric:
Amount on hand: Amount to buy:	Amount on hand: Amount to buy:
Fabric:	Batting:
Amount on hand: Amount to buy:	Amount on hand: Amount to buy:

SHOPPING LIST *(Thread, Rulers, Basting Spray, Needles, Fabric Glue)*

- [] - []
- [] - []
- [] - []
- [] - []
- [] - []
- [] - []

QUILT PLANNING

Project Name: _____

SWATCHES		PROGRESS CHART
Amount on hand: Amount to buy:	Amount on hand: Amount to buy:	☐ Fabrics pulled from stash ☐ Fabrics purchased ☐ Batting from stash or purchased ☐ Print paper piecing templates ☐ Test blocks made ☐ Pieced top ☐ Pieced backing ☐ Quilting designed & completed ☐ Make binding ☐ Make and attach label ☐ Photograph ☐ Send to recipient or keep
Amount on hand: Amount to buy:	Amount on hand: Amount to buy:	Amount on hand: Amount to buy:
Amount on hand: Amount to buy:	Amount on hand: Amount to buy:	Amount on hand: Amount to buy:

ABOUT THE AUTHOR

Carole Lyles Shaw is a quilt designer, author, teacher and lecturer. She started quilting many years ago by making quilts for her wonderful nieces and nephews. She has always taken a modern, improvisational approach to making quilts for the beds of her family and friends, sometimes incorporating her own hand-printed fabrics.

Today, Carole's focus is on designing modern quilts. She co-founded the Sarasota Modern Quilt Guild and served as a Board Member of The Modern Quilt Guild.

She lectures and leads workshops on modern quilting techniques for beginning and experienced quilters.

Many of her art quilts and modern quilts have been published in books and exhibited in shows in the U.S. and internationally. Carole accepts commissions for custom bed quilts and wall hangings.

Visit Carole's website, www.carolelylesshaw.com, for more information about her books, workshops, patterns and more.

OTHER TITLES BY CAROLE LYLES SHAW

Madly Modern Quilts: Patterns and Techniques to Inspire Your Quilting Creativity Available on Amazon or at www.createspace.com/6008257

Madly Modern Patterns will launch in late 2017. Patterns will be available in local quilt shops and online at CaroleLylesShaw.com.